THE THREE GRACES

The Three Graces
An Epic Poem Illustrated
by Catherine L. Morris

Copyright © 2024 by Catherine L. Morris. All rights reserved.
All words and works of art contained within this collection are originals by Catherine L. Morris. The media for the images are oil and gold leaf on wood panel. No part of this book may be reproduced without the permission of the artist. This book is published by New Classic Books, an imprint of Code Publishing, *www.code-interactive.com*.

ISBN: 978-1-60020-004-5
1-60020-004-4

FOREWORD

THE THREE GRACES have long been seen as representative of beauty in our culture, portrayed as such especially in the visual arts, painting and sculpture. There was a time in our recent past when it was not uncommon to encounter a statue or painting of three naked young women dancing playfully, arms entwined, at the park, the main plaza, or in the walls of a temple or civic building. You could see them anywhere the patrons wanted to beautify the space. Of course, the Three Graces were enlisted for this task because they represent beauty in essence, but also because they do so par excellence since they are in form the very essence of beauty—three delightful nude women.

It is not yet illegal to claim that the nude female form is a thing of beauty. There is something unmistakable about it that defies modern obfuscation of thought and egalitarianism. Her gentle curves, her exquisitely proportioned features, her long, flowing hair. Human symmetry is perfected with the woman's pair of breasts and her accentuated hips. The Italian jurist and writer Andrea Alciato (1492-1550) was once asked, "Why are they naked?" to which he replied, "Because loveliness resides in honesty of mind and pleases through its utter simplicity."

But the number of bodies in our display plays a role as well. From time immemorial, we have represented things using threes. In physics, we experience the world in three dimensions; in design, we see three primary colors; in rhetoric, we convince with three points. Socio-politically, three is the form of the family unit—father, mother, and child. Christian tradition holds that three is the number of divine Persons in the Holy Trinity quite as if it is logically necessary.

And so it is: In mathematics, three is the only number that equals the sum of its previous integers and the largest number in which the sum of it and its previous numbers equals the multiplication of it and its previous numbers. If there is one, there must be two, and if there are two, then there must be three.

We see the power of three most clearly in the

triangle, the most basic of all shapes and the only polygon where its points can be equidistant from each other. The triangle is also the most stable shape and serves as the foundation of the most efficient structures such as the geodesic dome.

Tradition presents the graces by many different names, but, no matter what they are called, they are almost always limited to three. Hesiod named them Aglaea, 'shining', representing splendor and charm, Euphrosyne, 'joy', representing

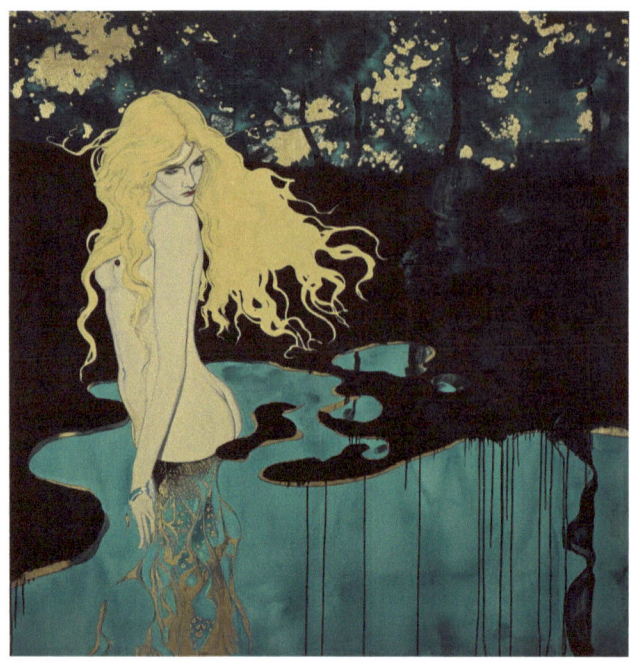

mirth and good humor, and Thalia, 'blooming', representing abundance or creativity. And, like the triangle, this triad of graces forms the most stable and efficient conception of beauty, comprised as it is of three equidistant and equally important virtues.

Other combinations of names found in the literature provide a similarly stable and efficient structure: Damia ('Earth Mother'), Auxesia ('Spring Growth'), Cleta ('Renowned'), Eupheme ('Good Omen'), Phaenna ('Bright'), Hegemone ('Leader'), Peitho ('Persuasion'), Paregoros ('Consolation'), Pasithea ('Relaxation'), Charis ('Grace'), and Kale ('Beauty'). Ancient vase paintings bear alternate names: Antheia ('Blossoms'), Eudaimonia ('Happiness'), Euthymia ('Good Mood'), Eutychia ('Good Luck'), Paidia ('Play'), Pandaisia ('Banquet'), and Pannychis ('Night Festivities').

All the references paint the Graces as working together to produce truth, goodness, and beauty, whence the Three Graces serving as Aphrodite's attendants. Just as a lady's attendants support her and allow her to be who she is, so too is it in the mythological. Beauty can only exist with the support and definition provided by splendor, joy, and creativity. This is a principle that permeates the Classical tradition.

Aristotle argues that beauty is the result of the graces, saying, in his Ethics, that "virtue aims at the beautiful." And so, as we see, beauty is only possible with support from growth, happiness, fortune, and play.

In our modern culture, this might seem not only foreign but blasphemous. We have not altogether gotten rid of the concept of beauty, but we have evolved its meaning. In the last century or so, we have come to supplant the notion of virtues with a social worth, so that a woman is more likely to be described as 'attractive' rather than 'beautiful'. Whereas beauty was about the object (the woman's face), attractiveness is more about the subject (the viewer of the woman's face). These days, beauty is in the eye of the beholder, not in the woman's face.

Ironically, it is this social conception of beauty that has turned women into objects of sexual gratification. When beauty is not viewed objectively, the woman becomes an object. Thus, the subjective view of beauty objectifies women. When beauty is seen merely as attractiveness, then the value at stake is the sexual pleasure that the viewer receives, debasing what would otherwise be pure and true.

This is how we've arrived at the paradoxical point in our culture where you can't show a naked woman on the television, but you can talk all you want to about deviant sexual relationships. Sex without nudity—attractiveness without beauty—is the defining characteristic of our decadent arts.

Egalitarians will trumpet the change. When beauty is seen merely as attractiveness, or what one can give to the other, it becomes a social thing, which anyone can provide. It is no longer a matter of achieving virtues of integrity, proportion, and clarity; rather, it becomes a matter of being able to stimulate and satisfy others sexually. These days, this is best

conveyed by gestures that flout traditional mores, to flout the graces: Not only by dressing less, but by dressing seductively, accentuating breasts and hinds, and by indicating an inclination toward rebelliousness as with tattoos, piercings, and edgy behavior like drinking, smoking, and taking drugs.

But what happens when you flout the graces? Without the graces, there can be no beauty. And so, in a twisted fate, the modern attempt to attain beauty necessarily leads to her destruction.

Nor can it be denied that this change in mindset has led to another more recent turn of events, namely in the rise of gender ideology and its offshoots. Of course, the traditional view of the concept maintains that both men and women can be beautiful. But, this doesn't mean that beauty is not gendered. The ancients always held that men and women were beautiful in their own ways, men in an athletic and martial way, women in a supple and procreative way. As beauty no longer refers to the object, the traditional view of men and women no longer holds, and so one can choose, not only who one is, but what gender or sex one is. The emphasis is no longer on what one is, but what one can provide for the other, which has no limits and, as a result, no meaning.

As our heroine in this tale discovers, the destination of the new path is chaos, fear, hardship. The only way back is to rediscover the Graces. Only then, can we hope to find beauty again.

—Catherine L. Morris
San Antonio, TX

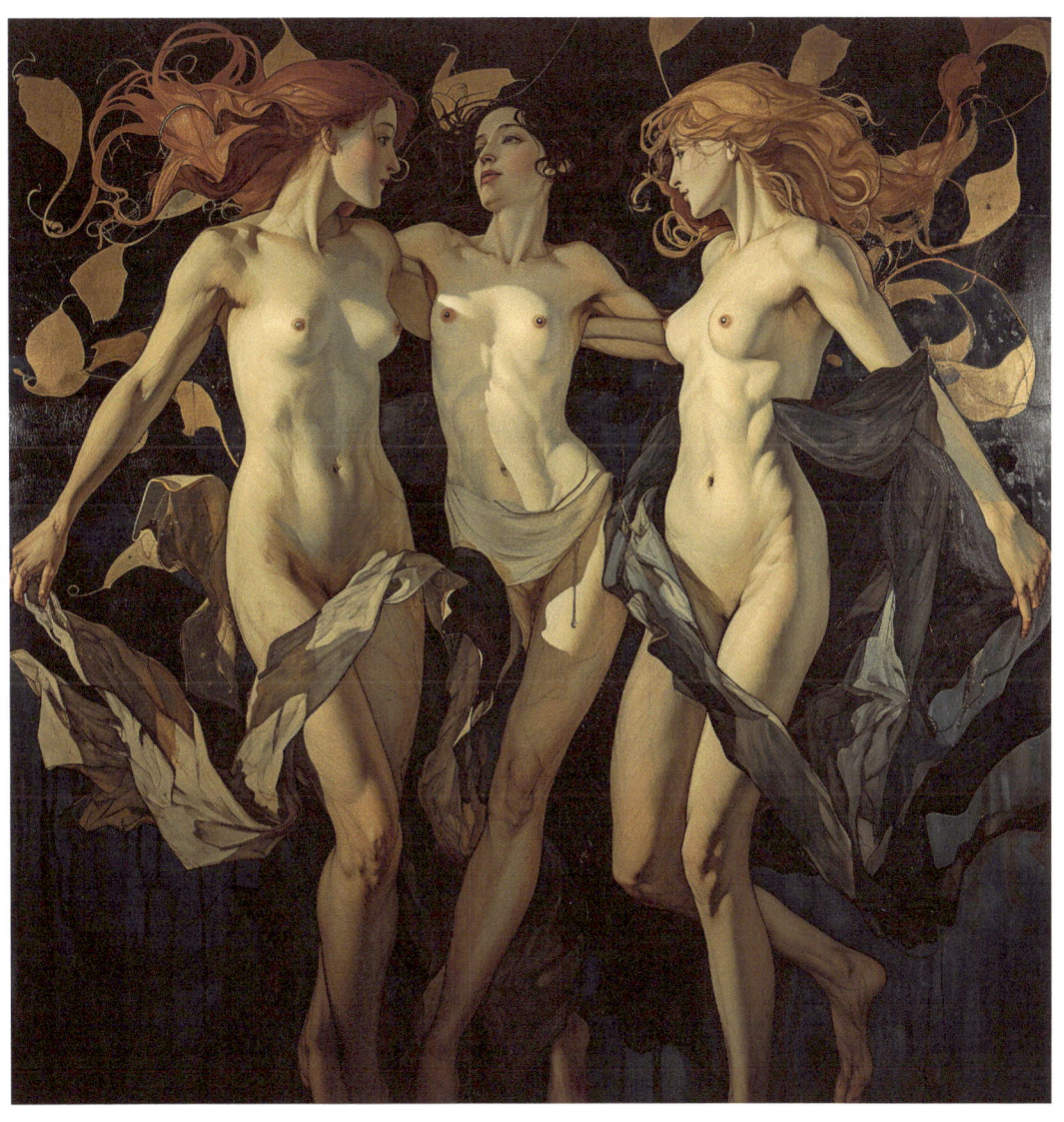

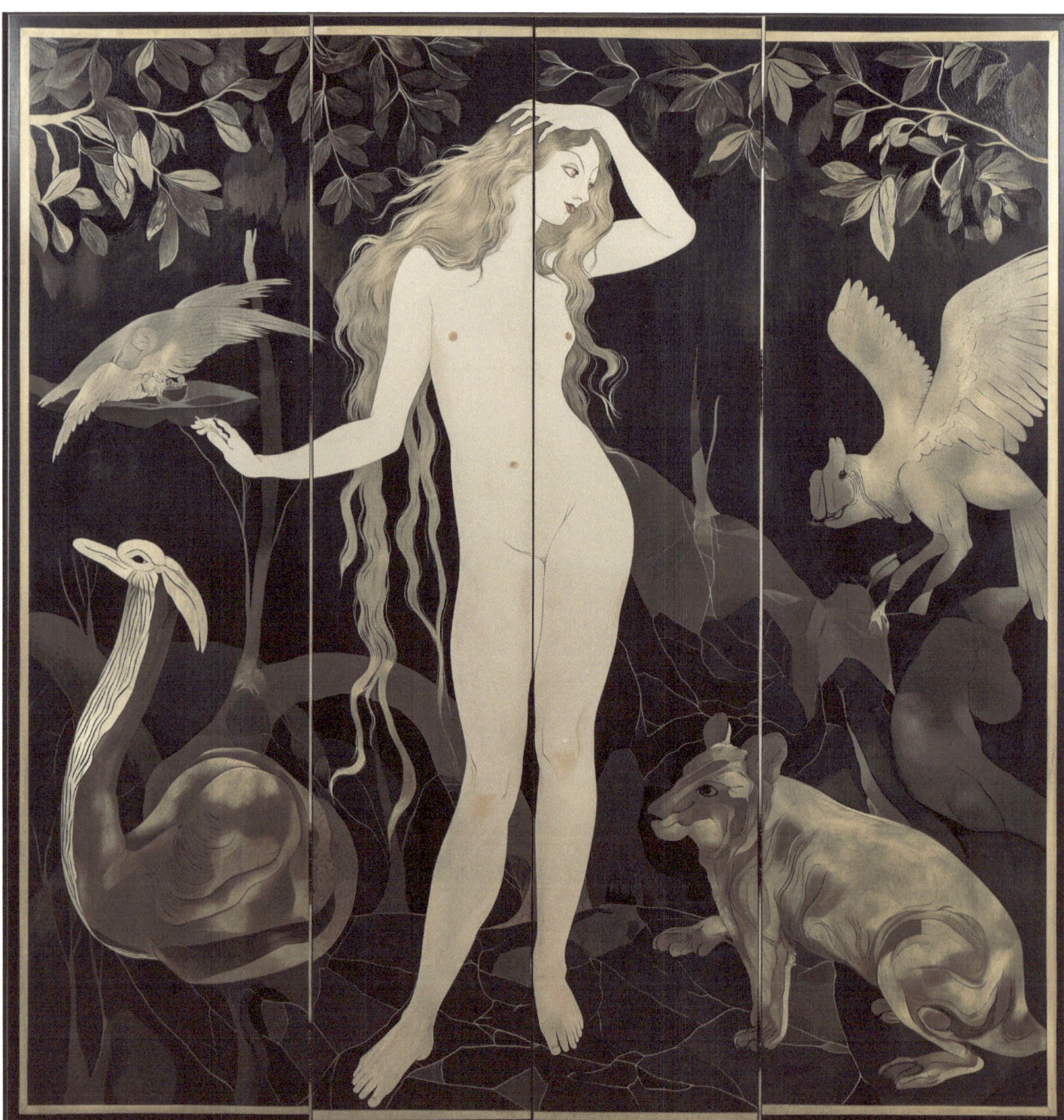

I

BEAUTY UNMATCHED

In realms divine, where gods in splendor shine,
Fair Aphrodite, beauty's guide designs.
With attendants by her side, unconfined,
Three Graces, in their charm, forever bind.

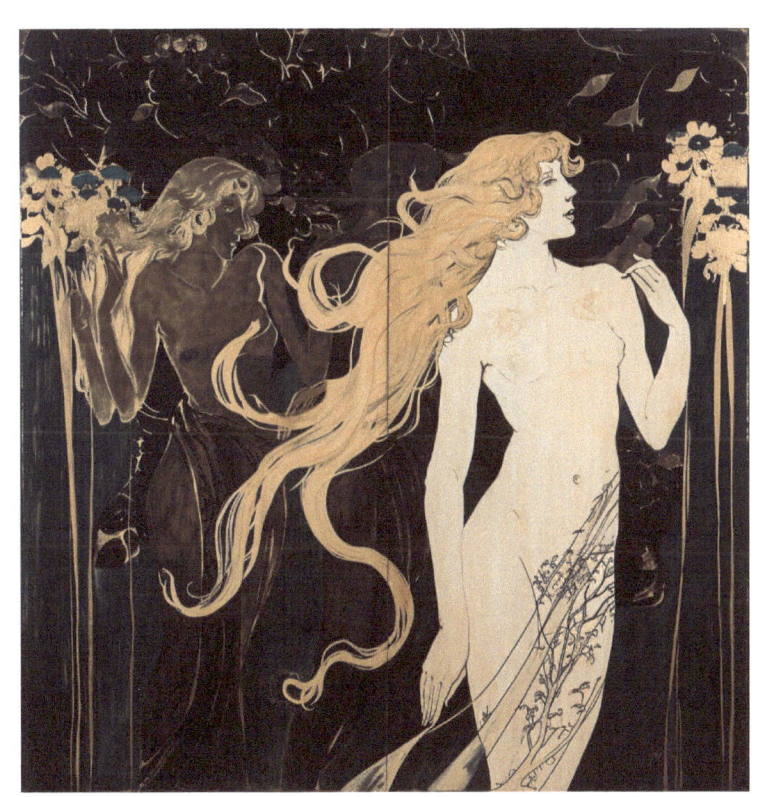

Aglaea, with splendor's brilliance ablaze,
Euphrosyne, joy's fountain, serenely stays.
Thalia, creativity's dance amaze,
Together, in grace, they weave ethereal rays.

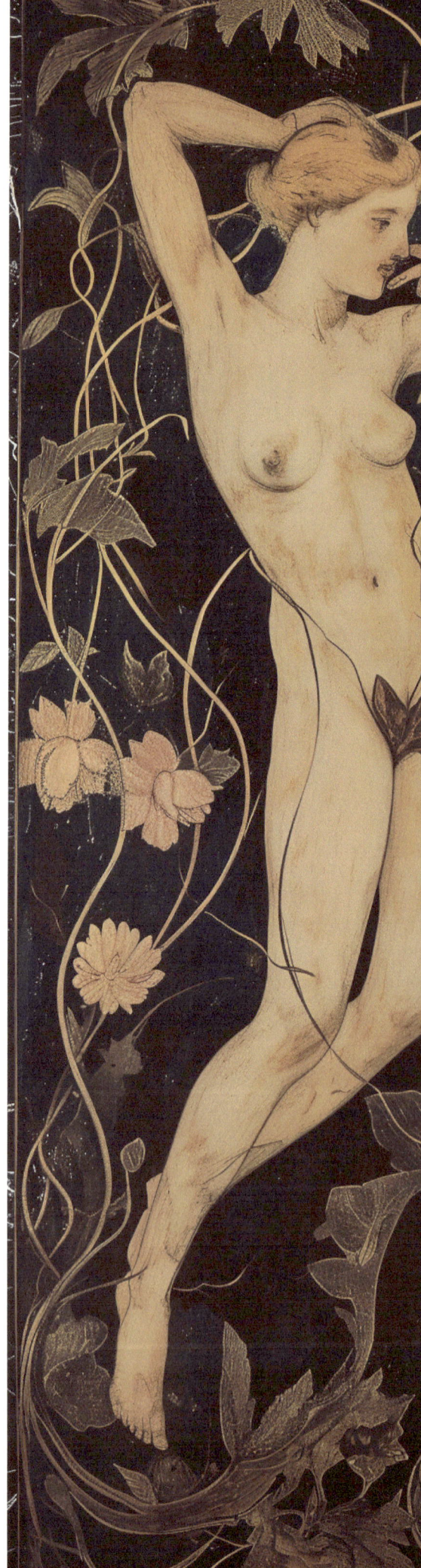

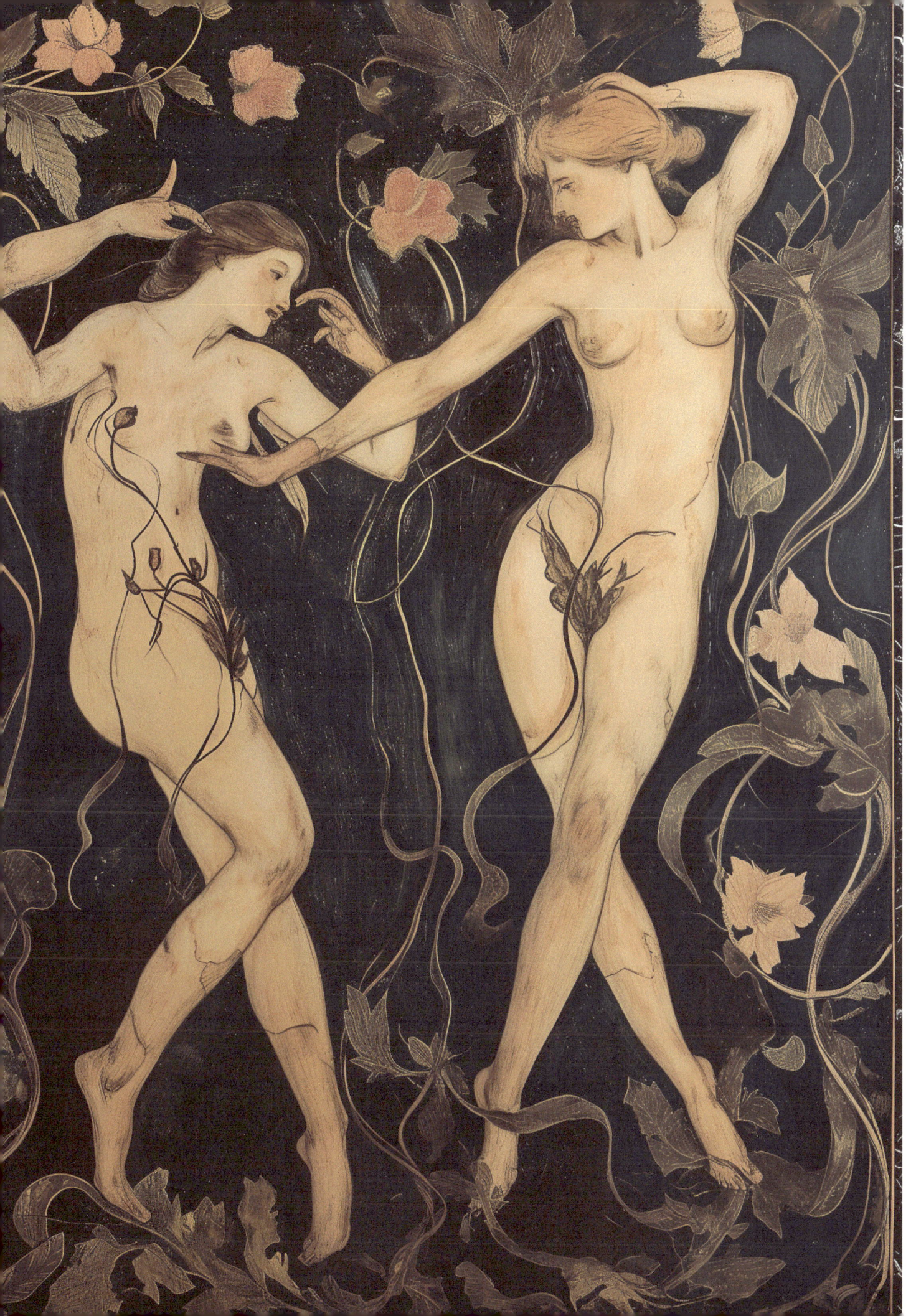

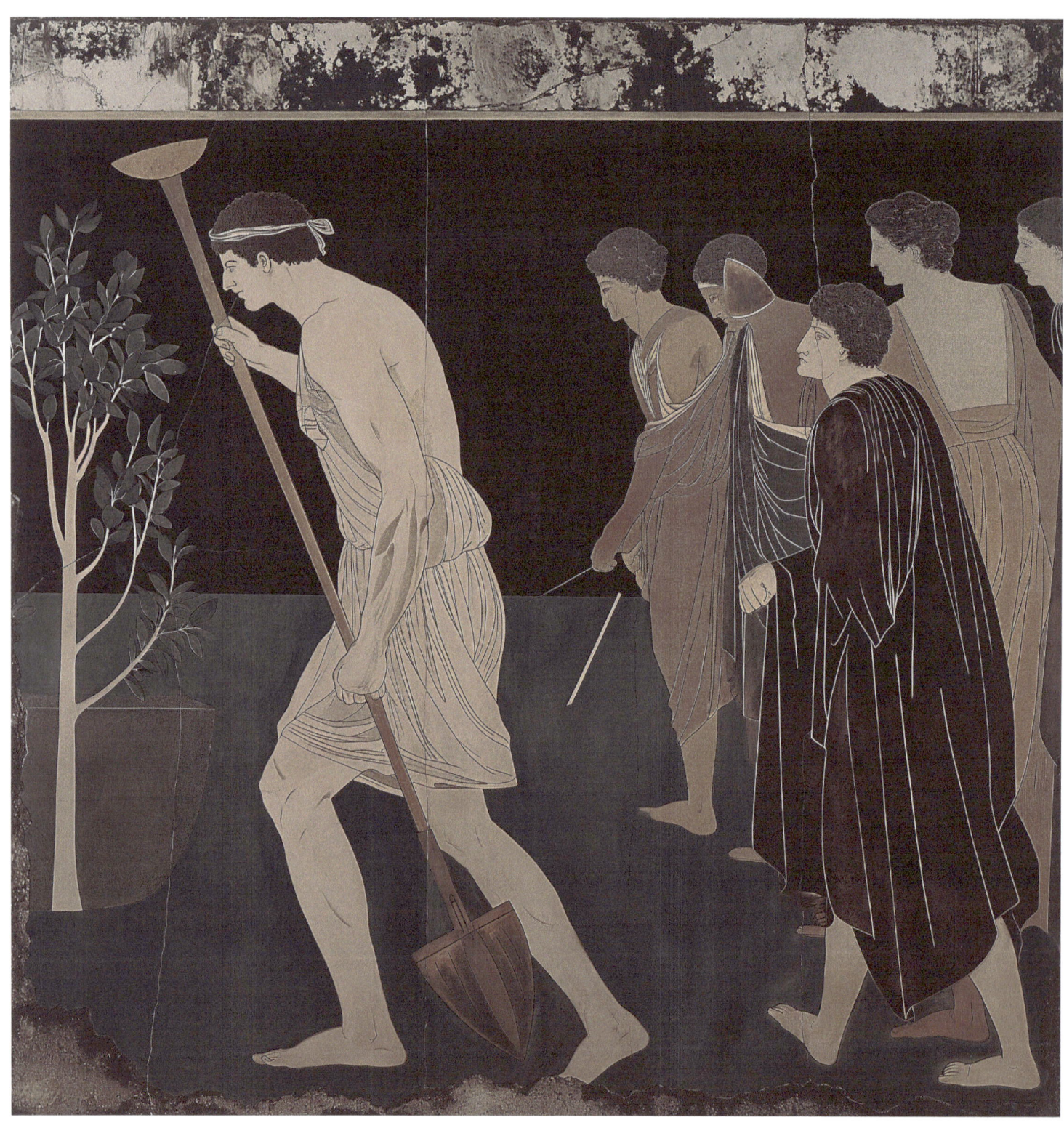

II

LOVE DEVOTED

Young men inspired, by her beauty aspire,
To toil and build, in love's celestial fire.
Dreaming of her visage, passion's lyre,
They offer their labor in zeal's attire.

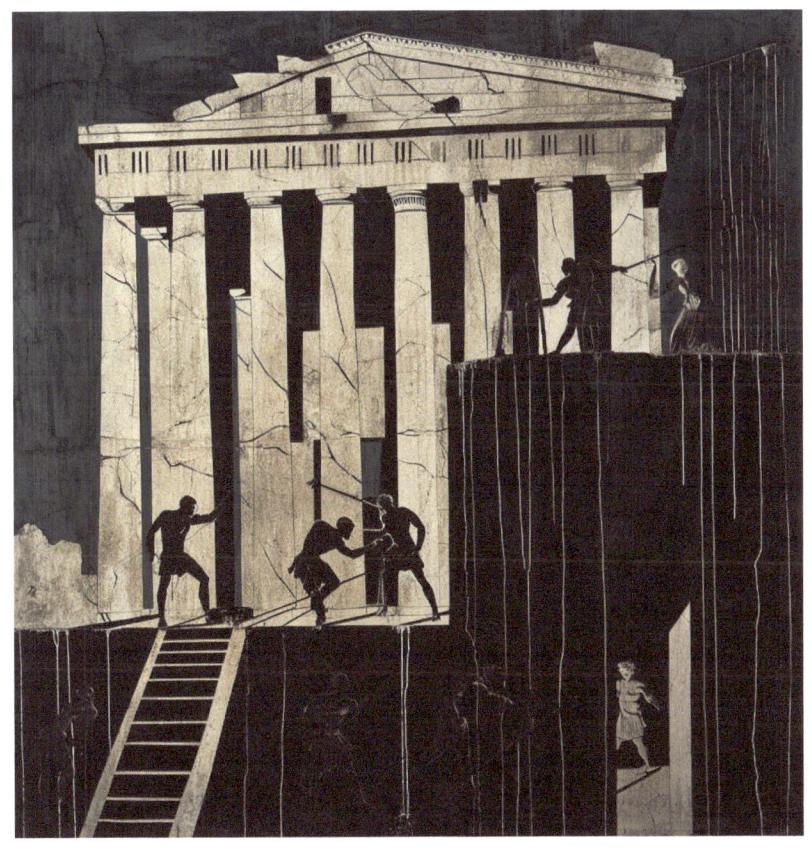

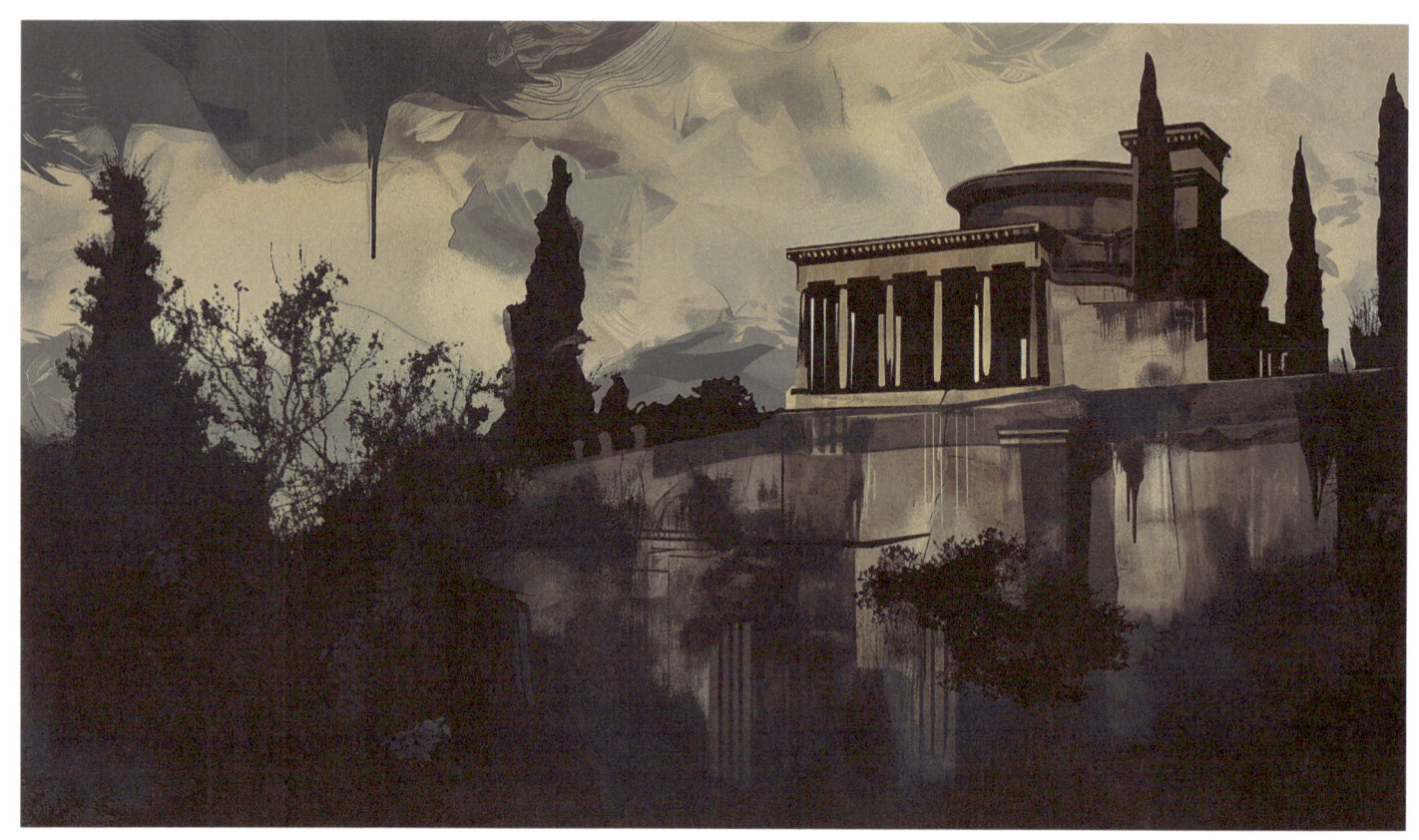

A king, handsome, with wisdom's sacred trace,
Announces a contest, a royal embrace.
His kingdom pledged, a noble showcase,
To the goddess crowned with beauty and grace.

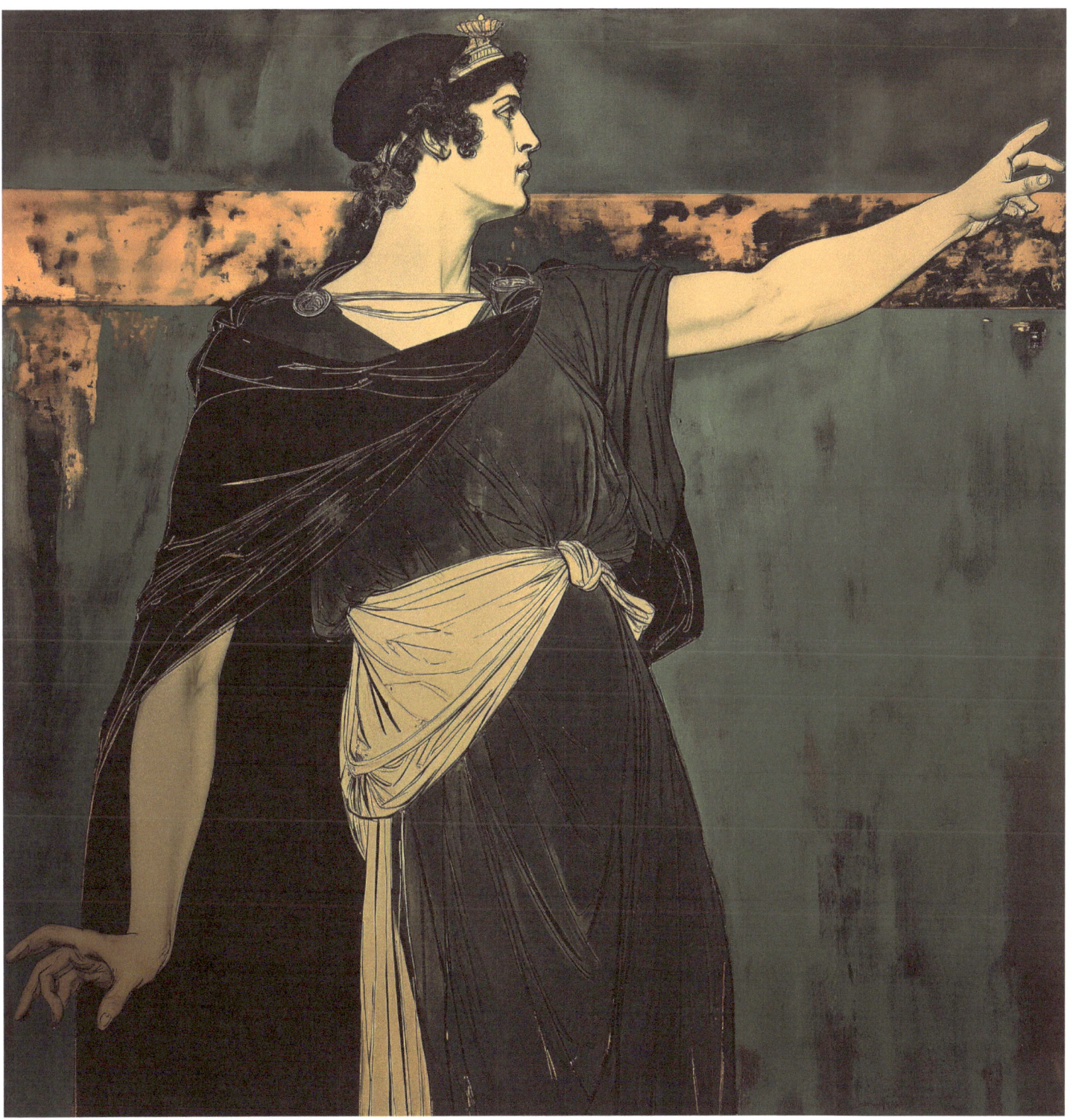

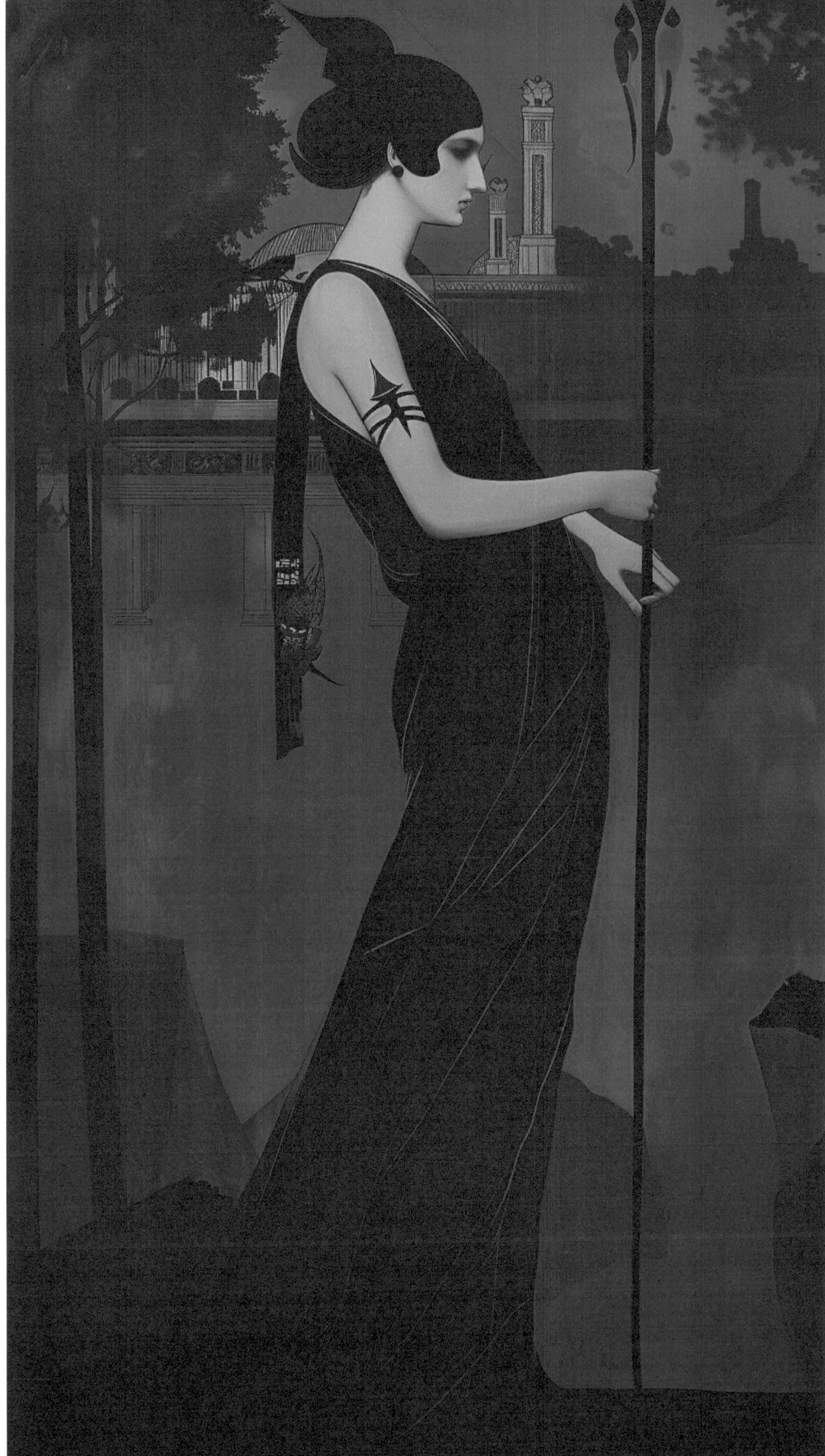

III

A RIVAL ENVIOUS

In chaste Artemis envious flames ignite,
Longs to dethrone, to claim beauty's height.
Yet, against Aphrodite, none could sleight,
Falter, fade, in envy's waning light.

A sly satyr with goatish features rare,
Spurned by Aphrodite, seeks repair.
Whispers plots, a web of dark despair,
To cast the Graces into slumber's snare.

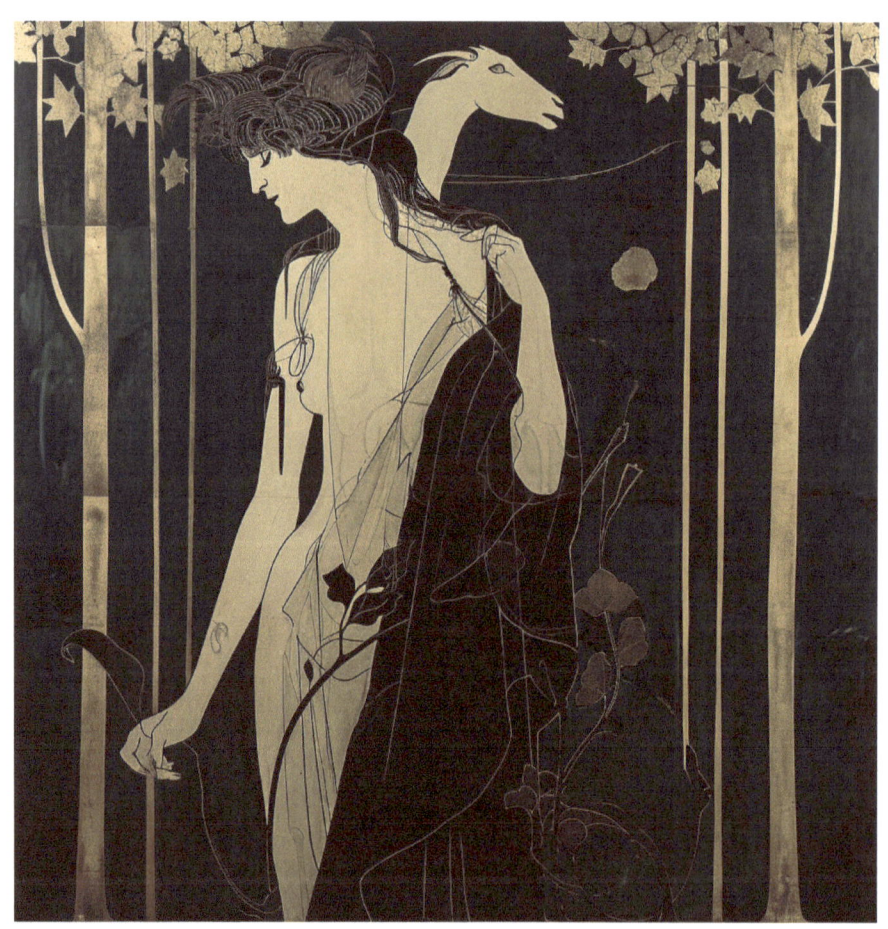

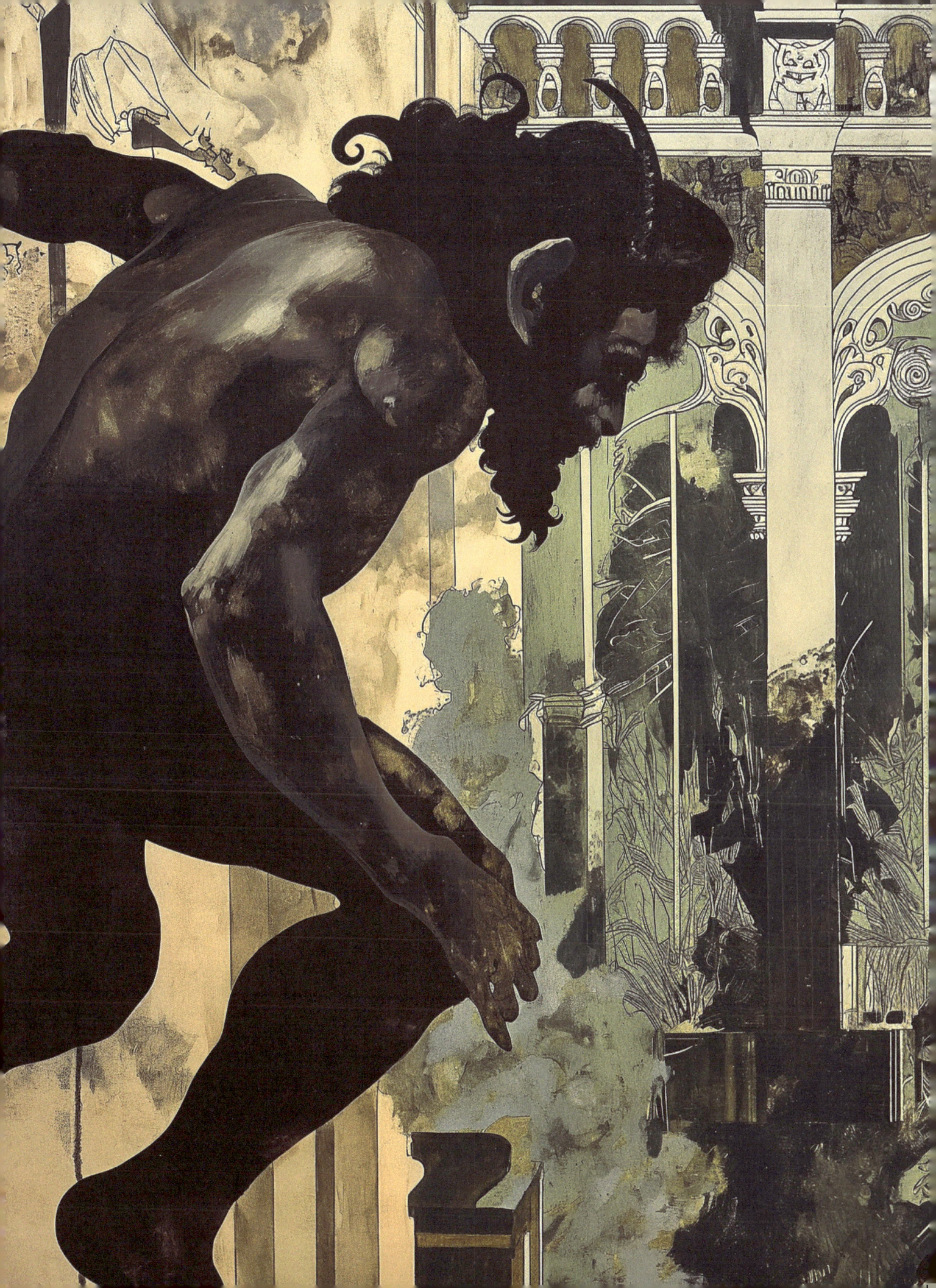

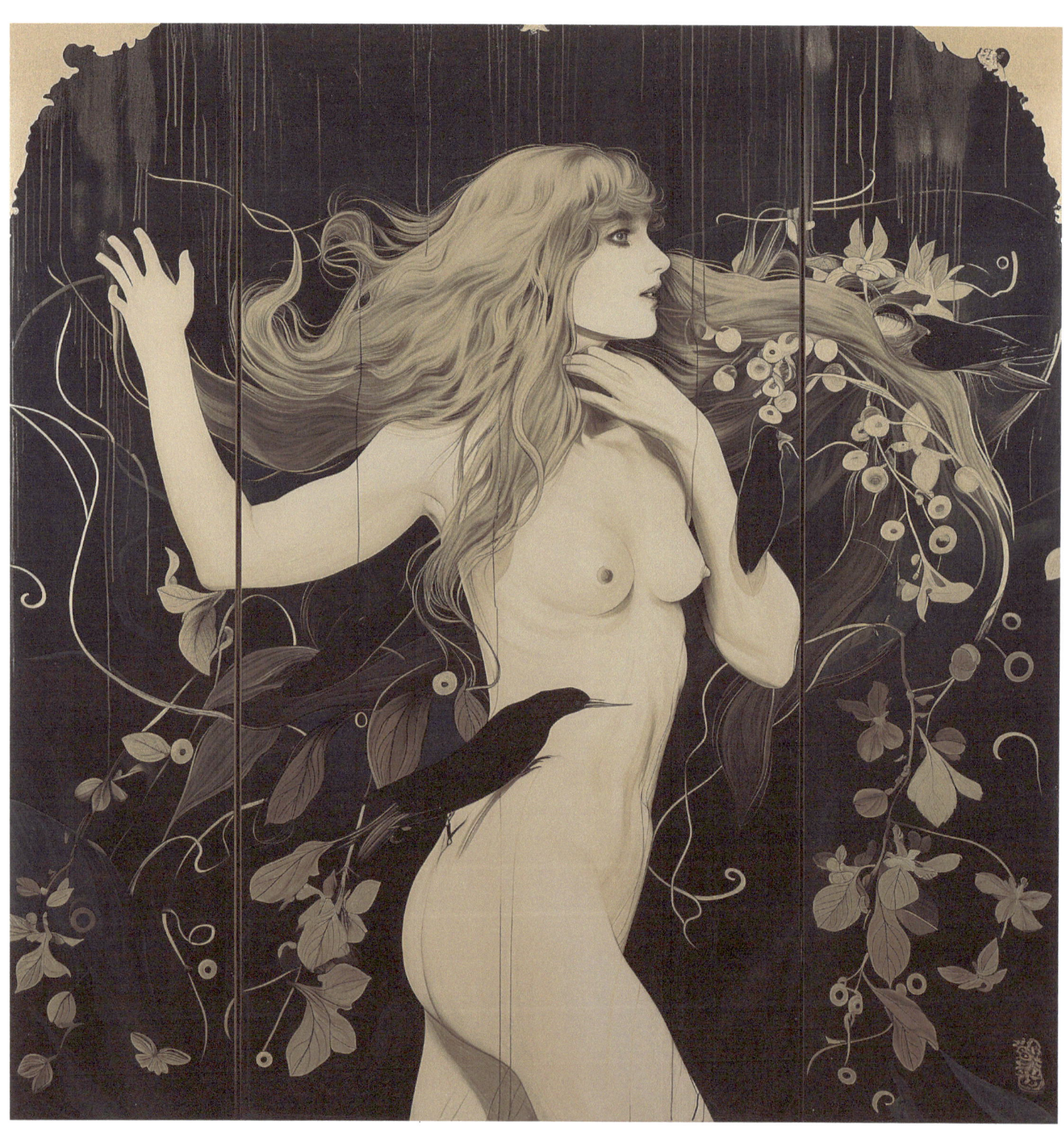

Unsuspecting, Aphrodite is caught
Apart from her Graces, an afterthought,
And vulnerable to satyr's ill plot
To replace Graces with three Vices haught.

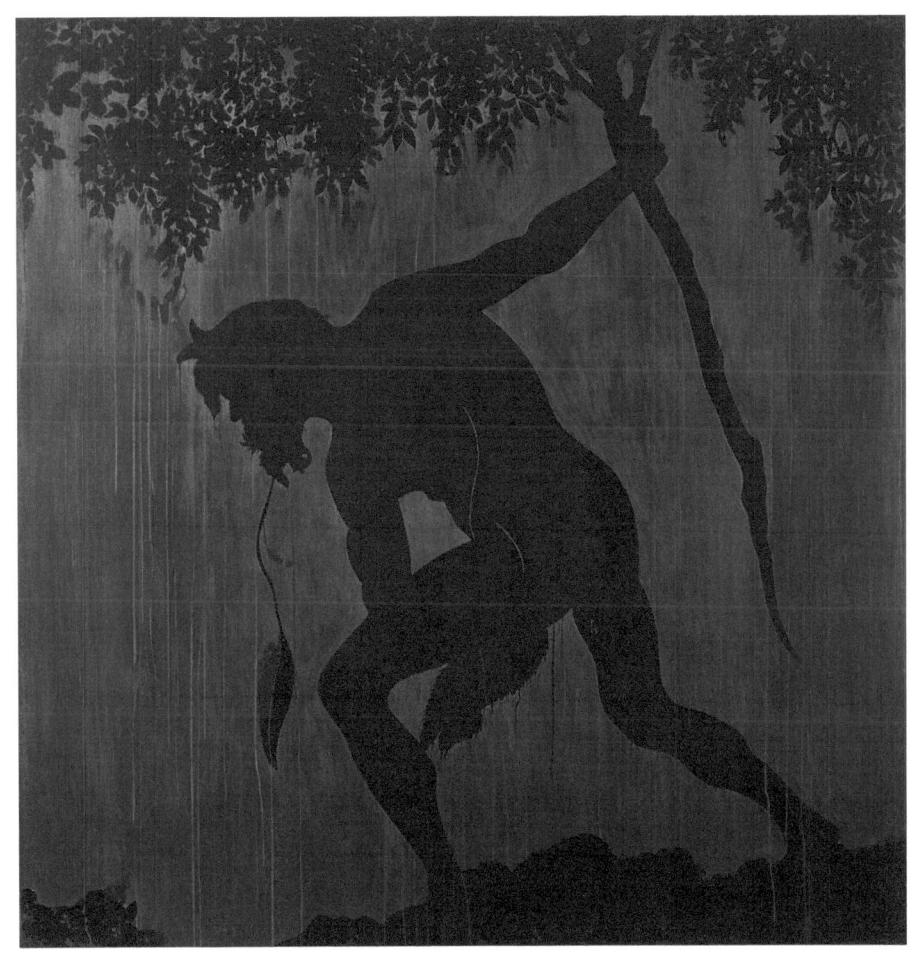

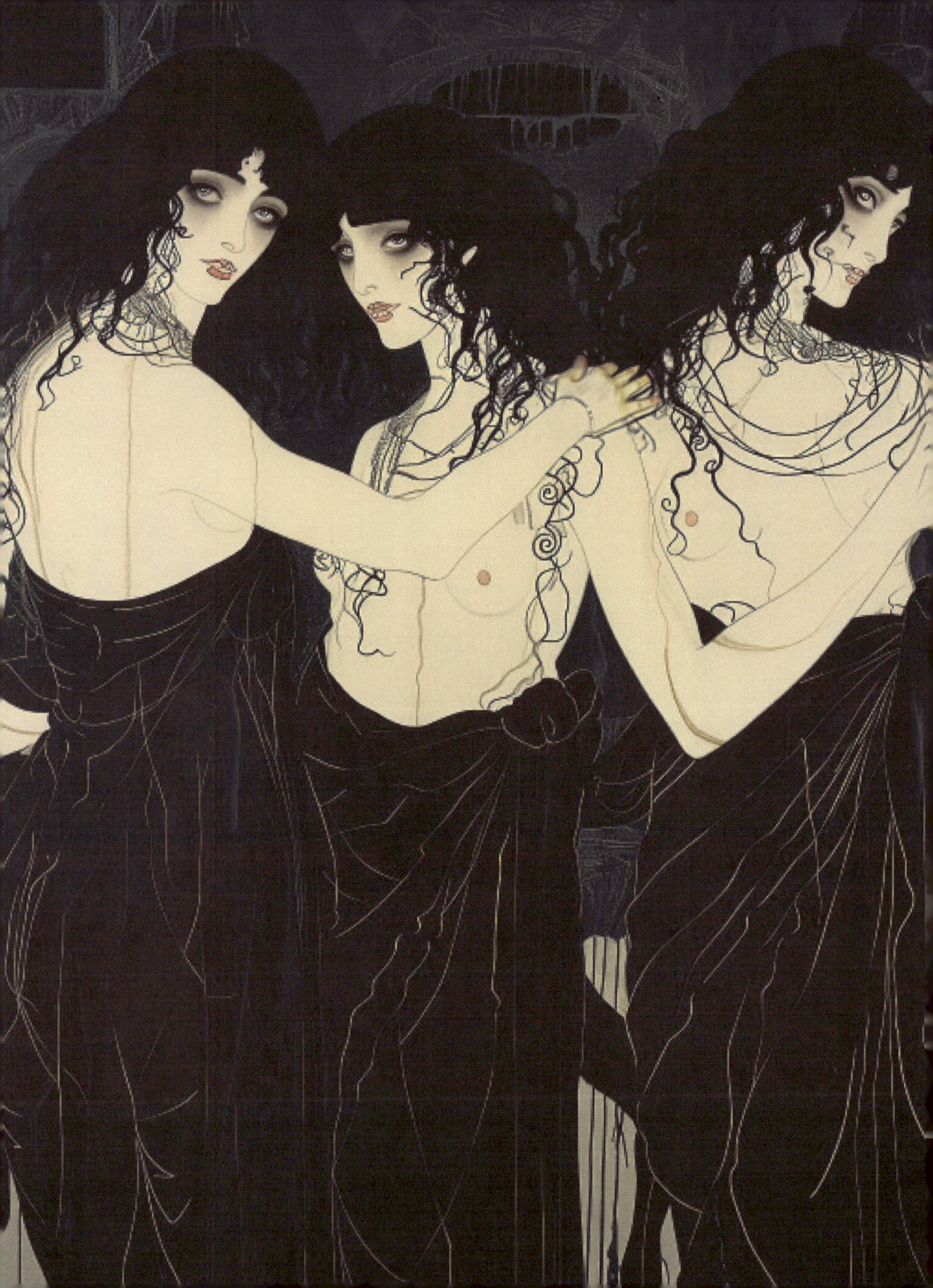

IV

A WICKED PLOT

Lasciviousness tempts with passions deep,
Gossip whispers secrets, power to reap.
Gluttony promises a banquet to keep,
Aphrodite ensnared in Vices' sweep.

Now to stupor, the Graces gently lost,
Traded for Vices, at a grievous cost.

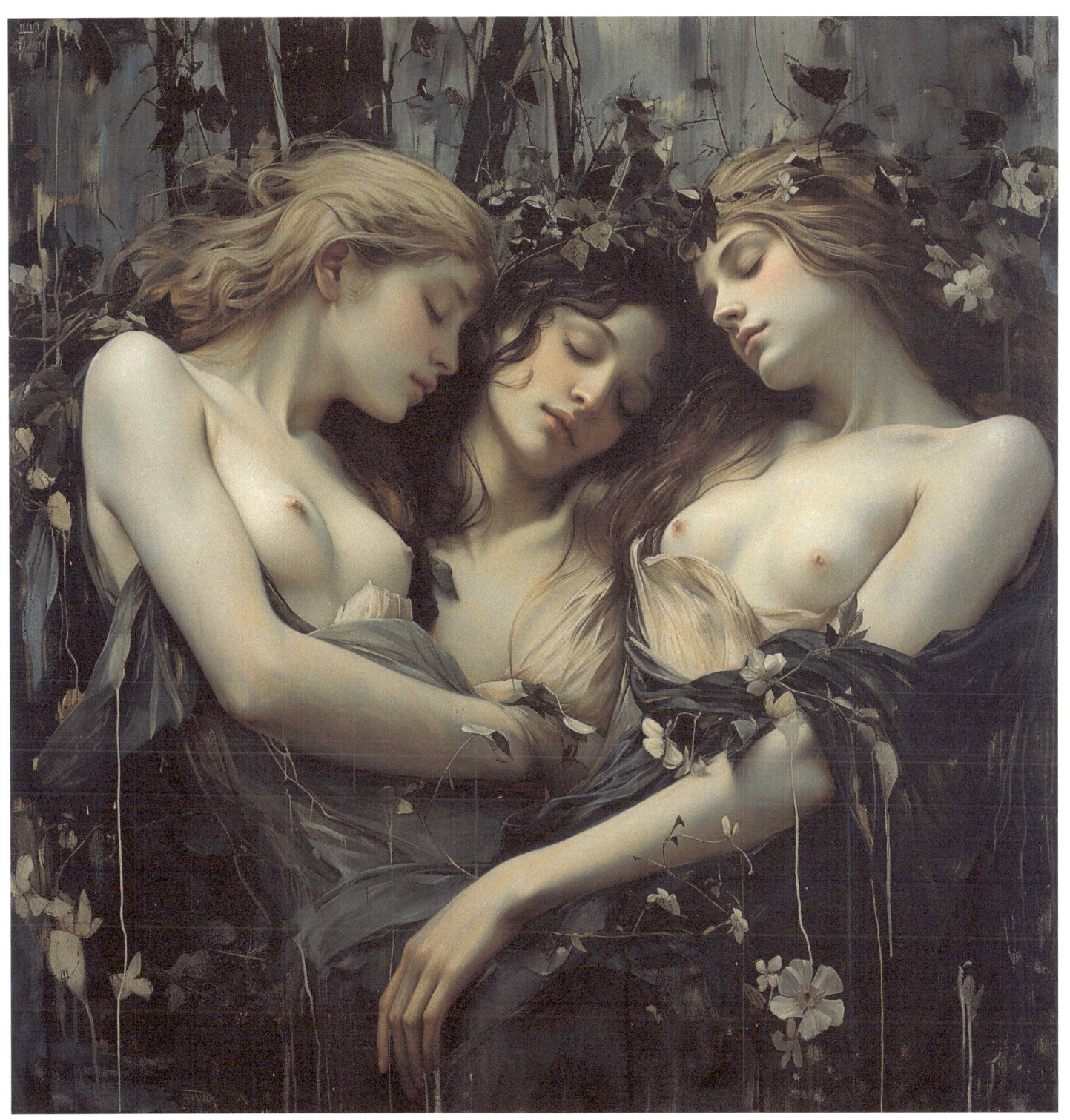

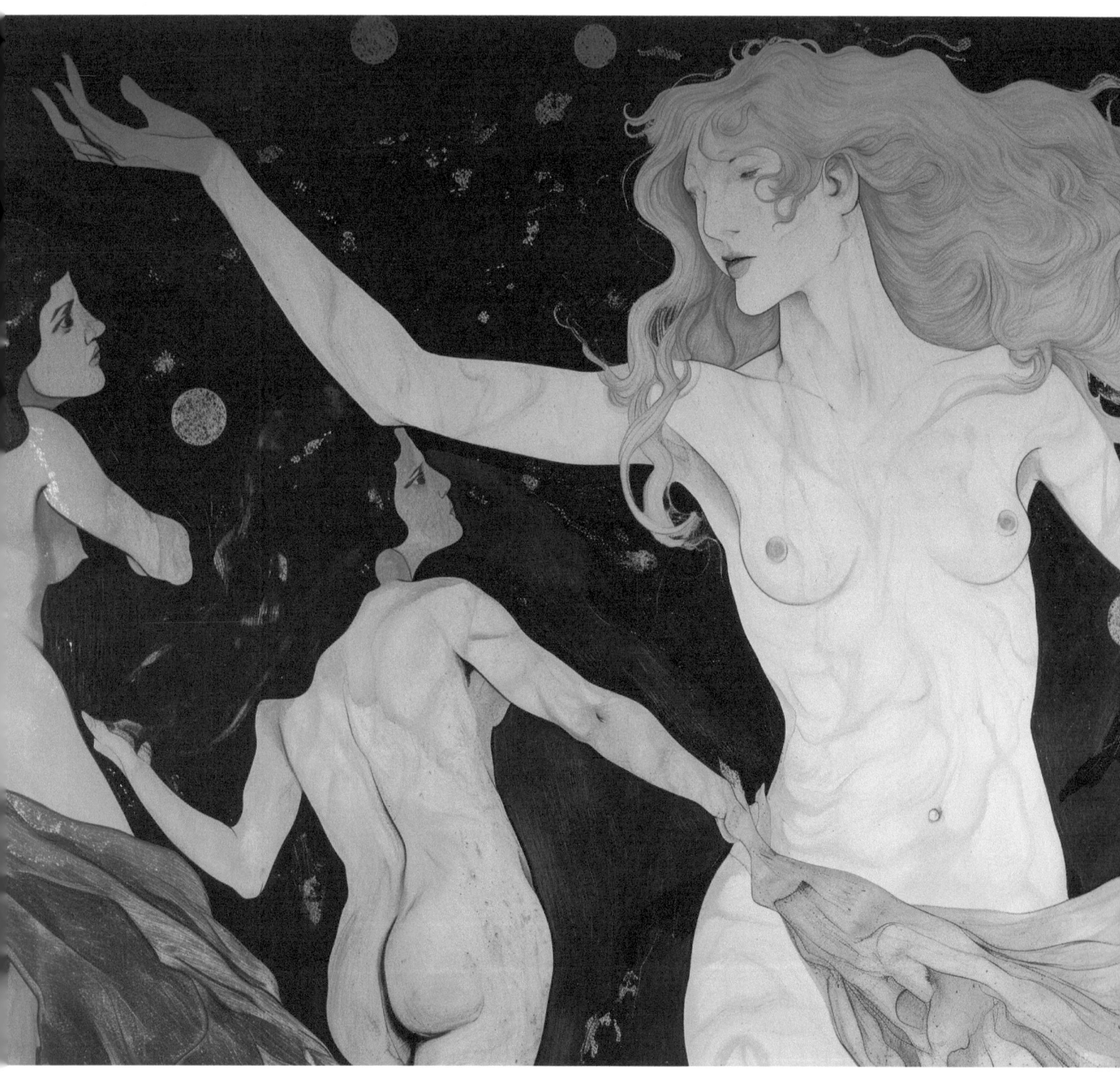

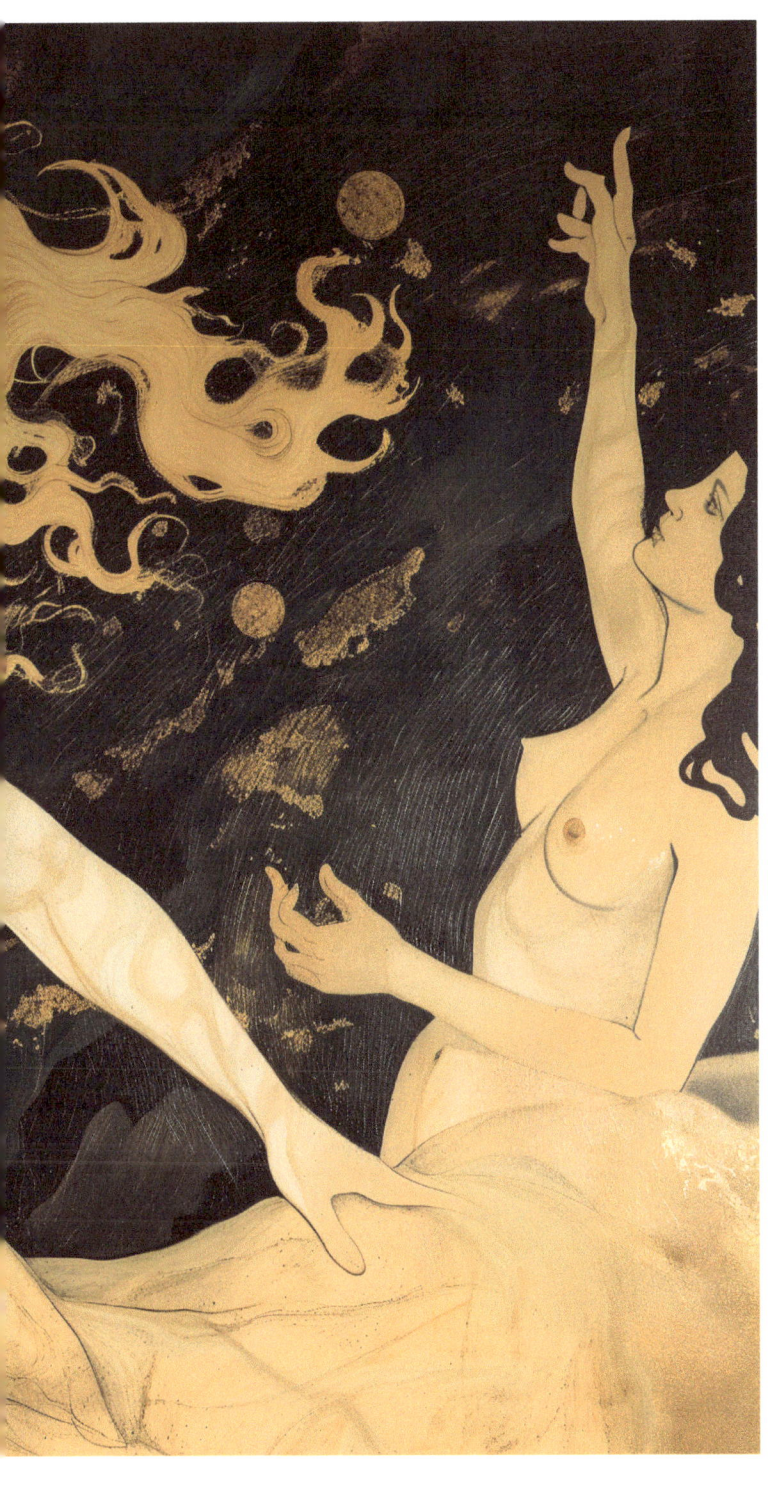

With new attendants,
love's spell is
embossed,
Eagerly, recklessly,
lustfully crossed.

V

THE CONTEST MISSED

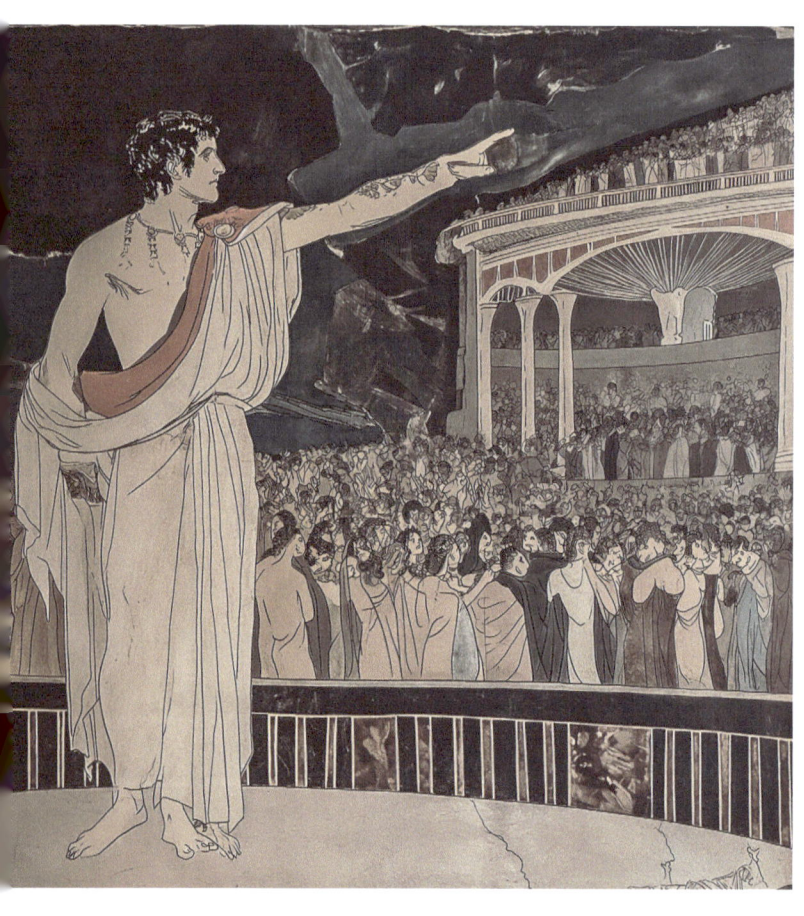

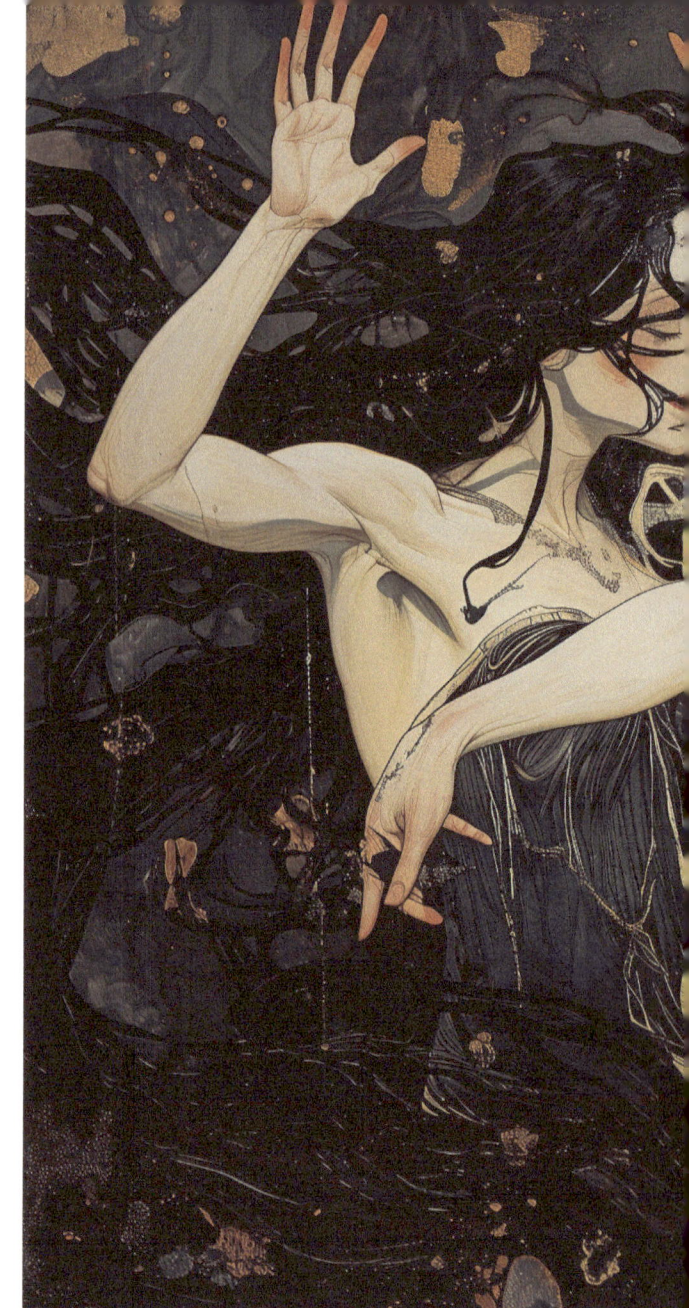

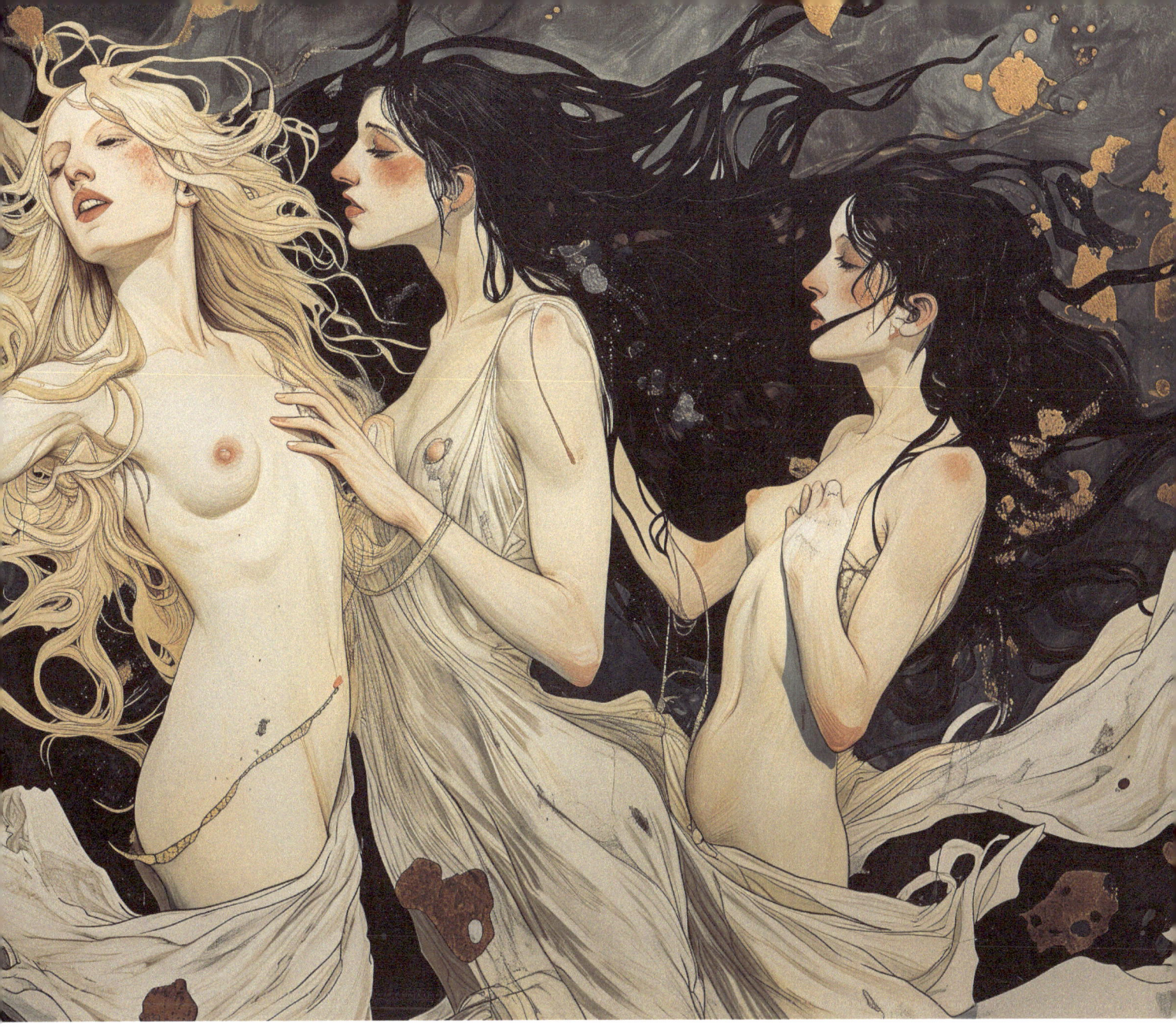

The herald calls, the contest's grandeur nears,
Aphrodite, blind to impending tears.
The Vices lead down a footpath that veers,
To temptations, illusions, beauty's tears.

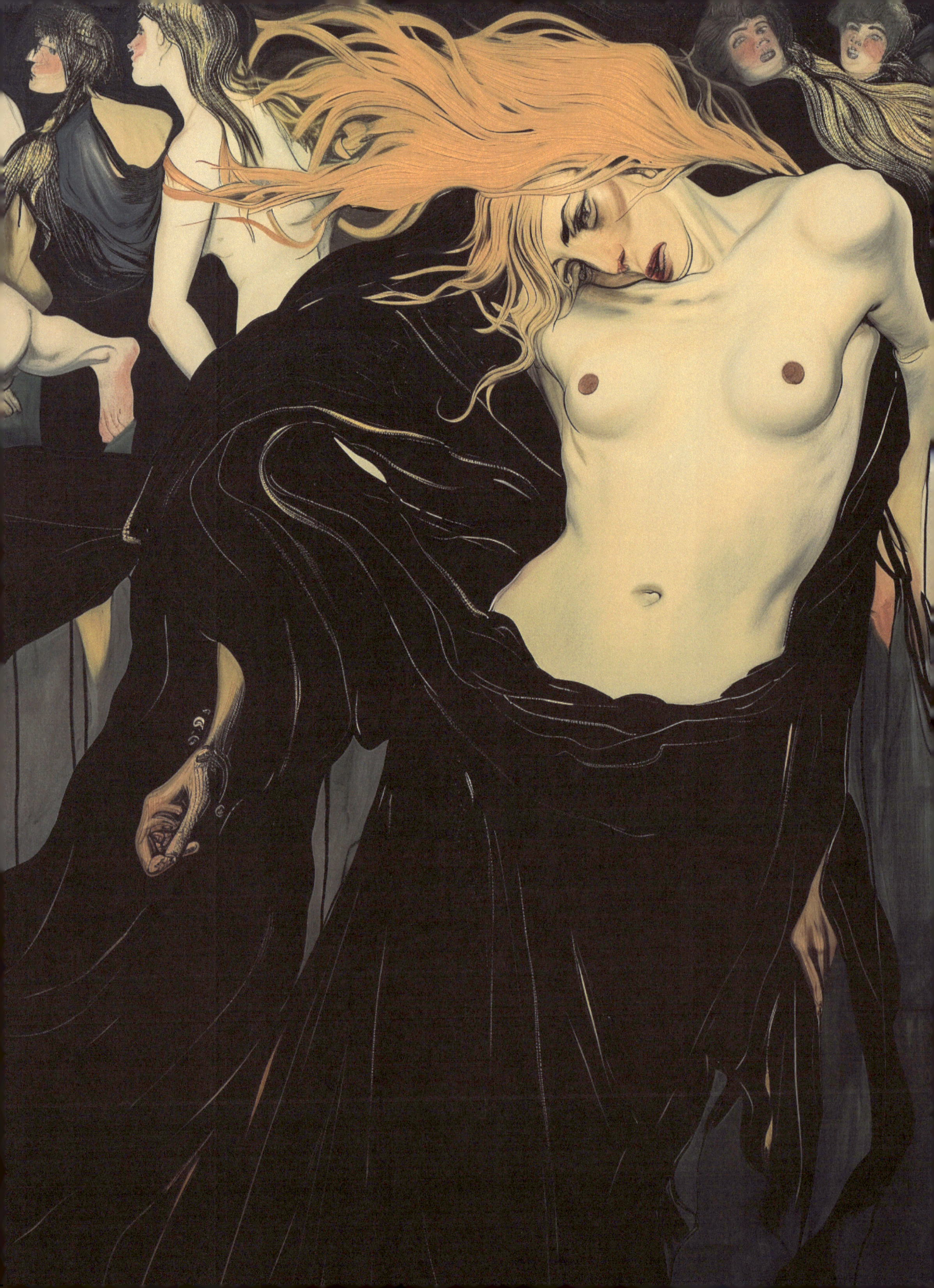

Pan, Dionysos, and revelers unite
To let loose, to dance, in the joyous night.
Yet the Vices stay, in their tempting night,
At the tragic cost of beauty's bright light.

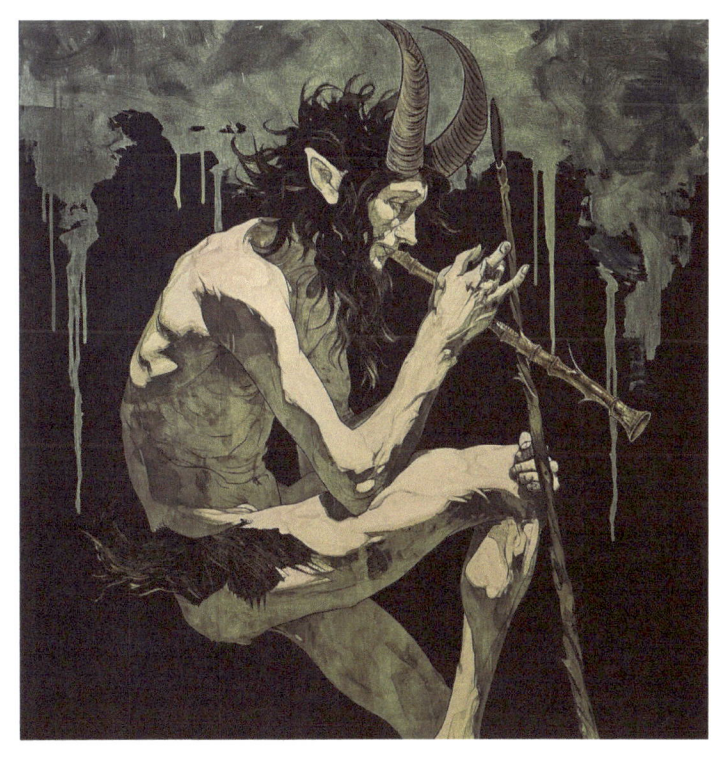

VI

BEAUTY'S DISMAY

The young man, once devoted, now estranged,
Treats her like the devil, emotions changed.

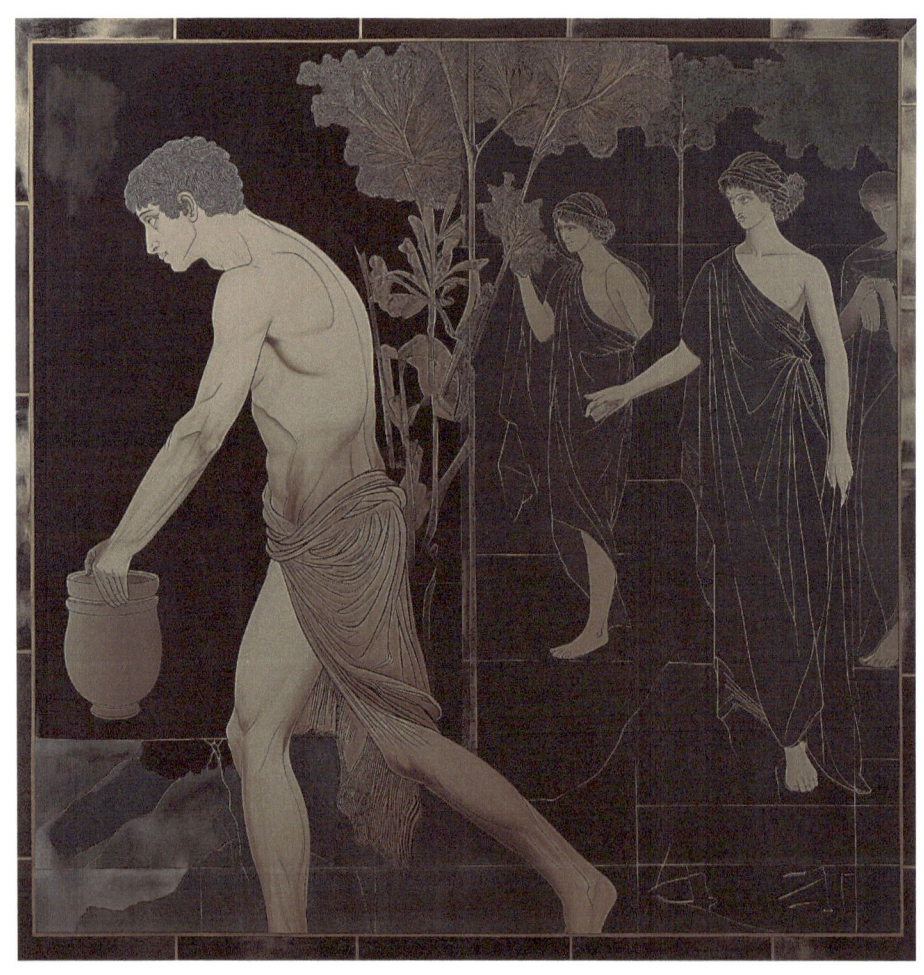

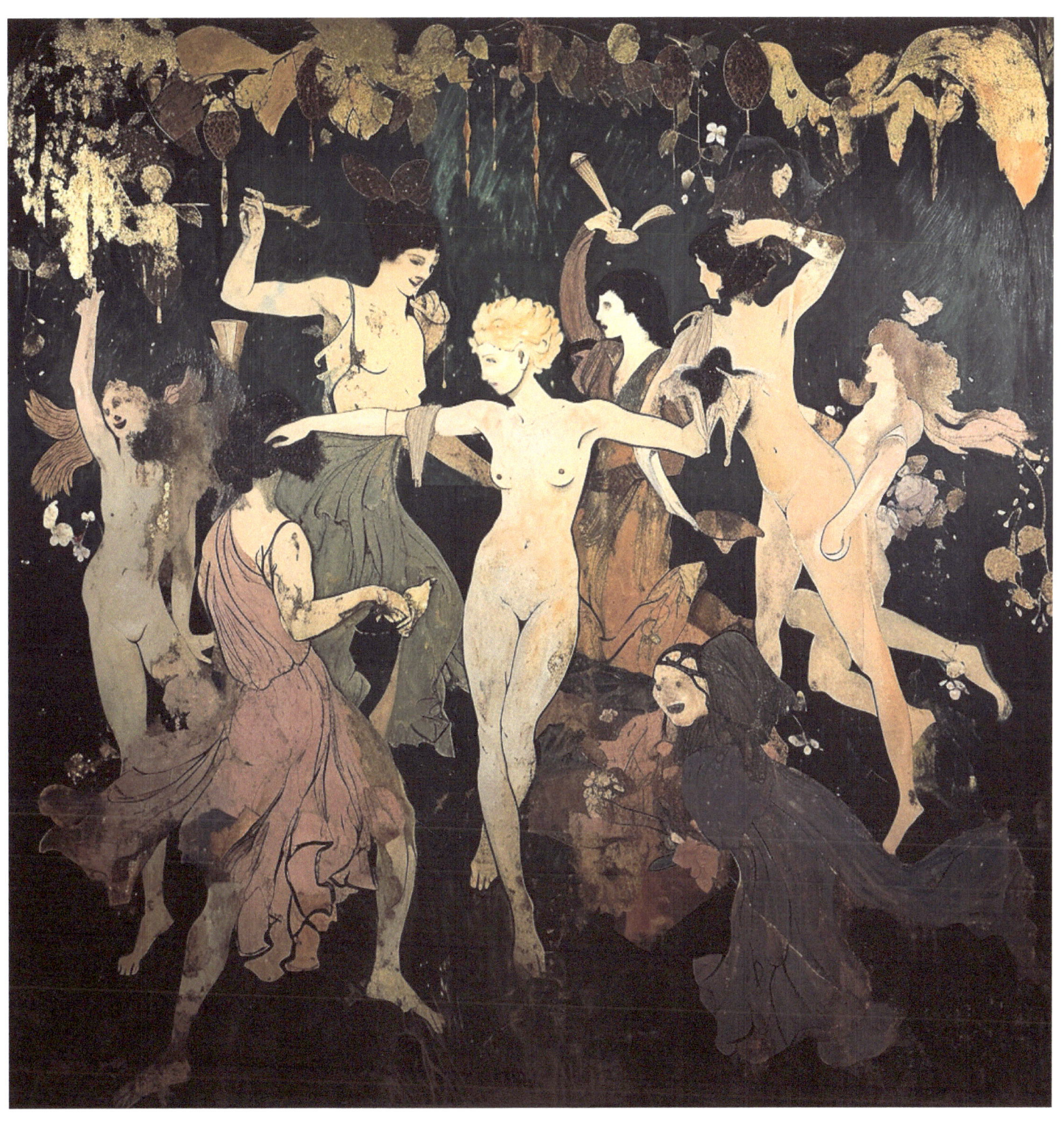

Now Ares arrives, the scene is deranged,
For Aphrodite's favor, hearts exchanged.

Escaping the melee, reflection's thought,
The wise owl descends, truth's lesson is sought.
Less beautiful, she, the owl's words are traught,
Aphrodite's pride, by witness is caught.

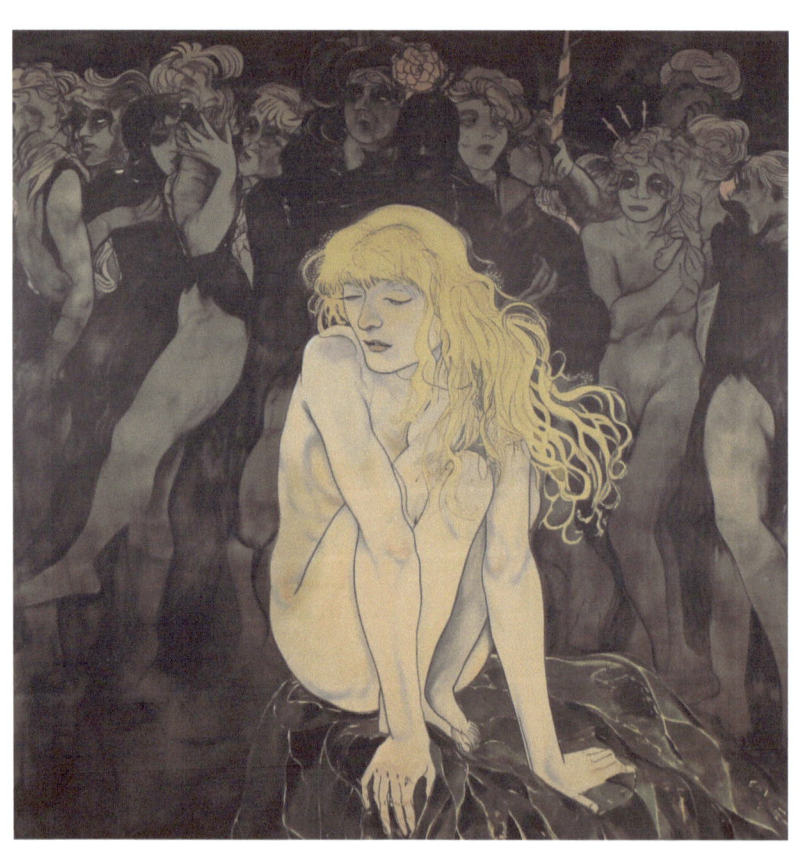

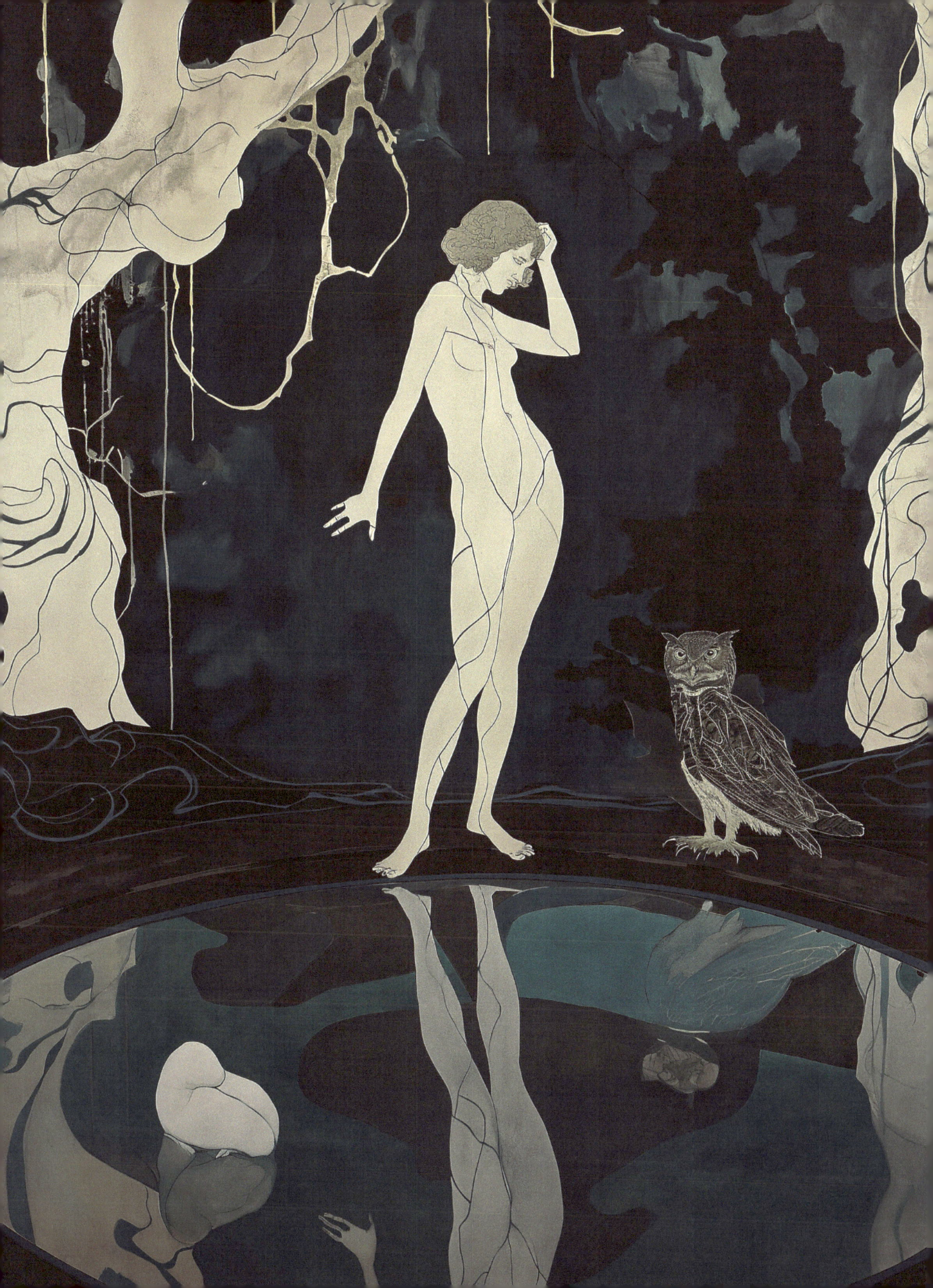

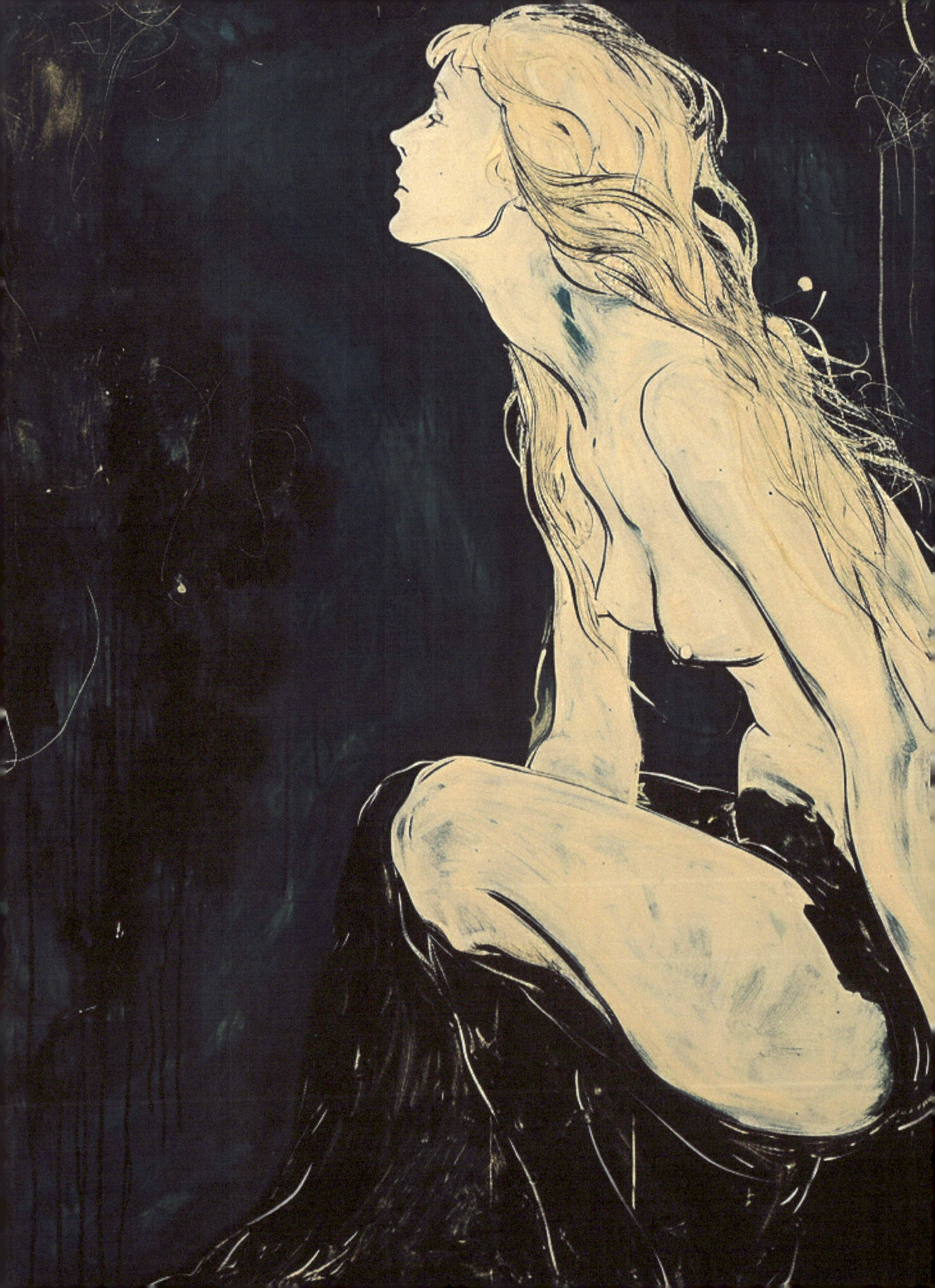

VII

A CONVERSION OF HEART

Realization strikes, her interest denied,
Aphrodite, in the truth, does she confide.
For solace she flees from this twisted tide,
To find her fair Graces three, lost beside.

'Twixt the wood, pure Graces frolic, plays,
Dancing in the light of the sun's array.

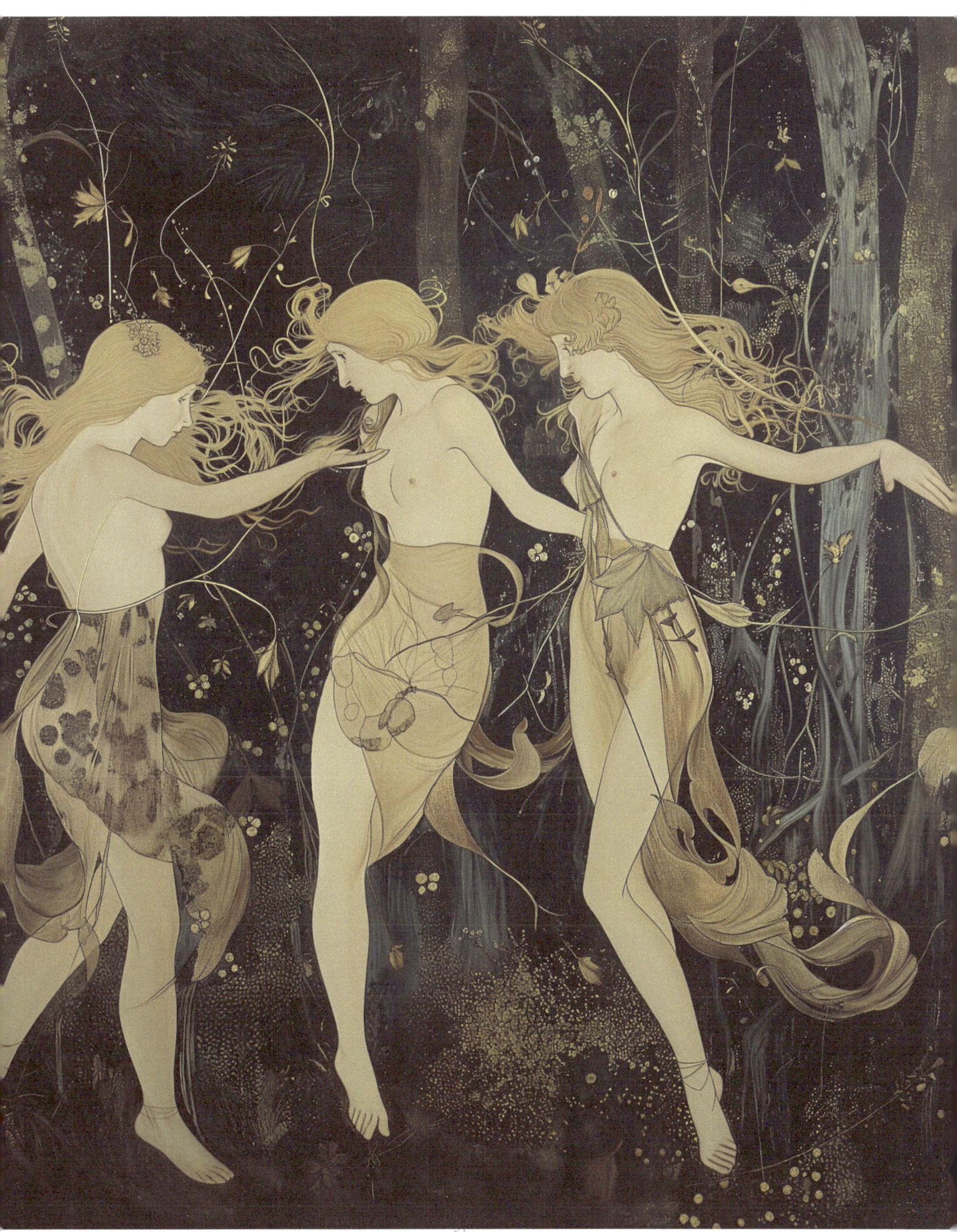

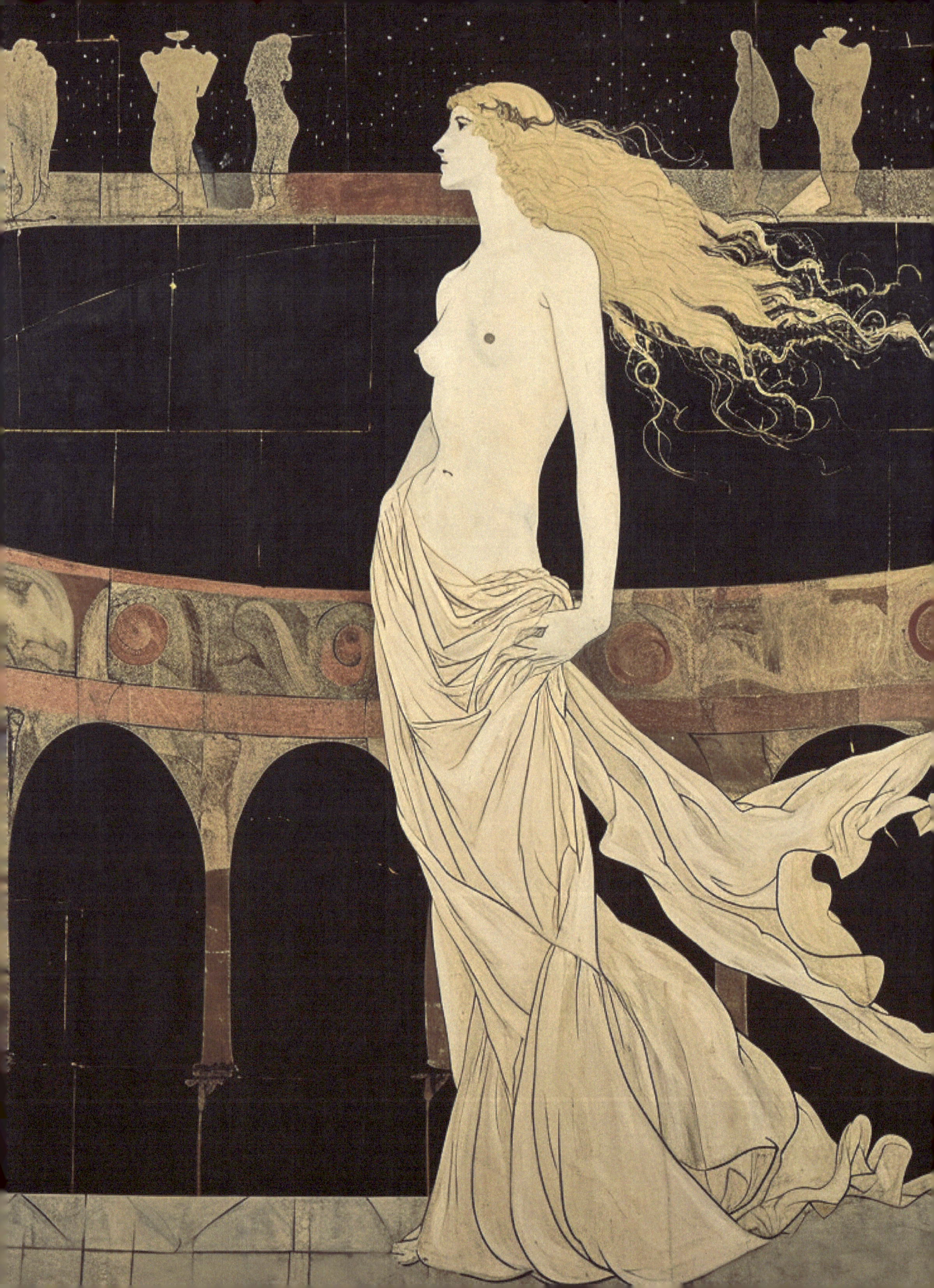

Aphrodite, with haste, does make her way,
To join in the contest, a final display.

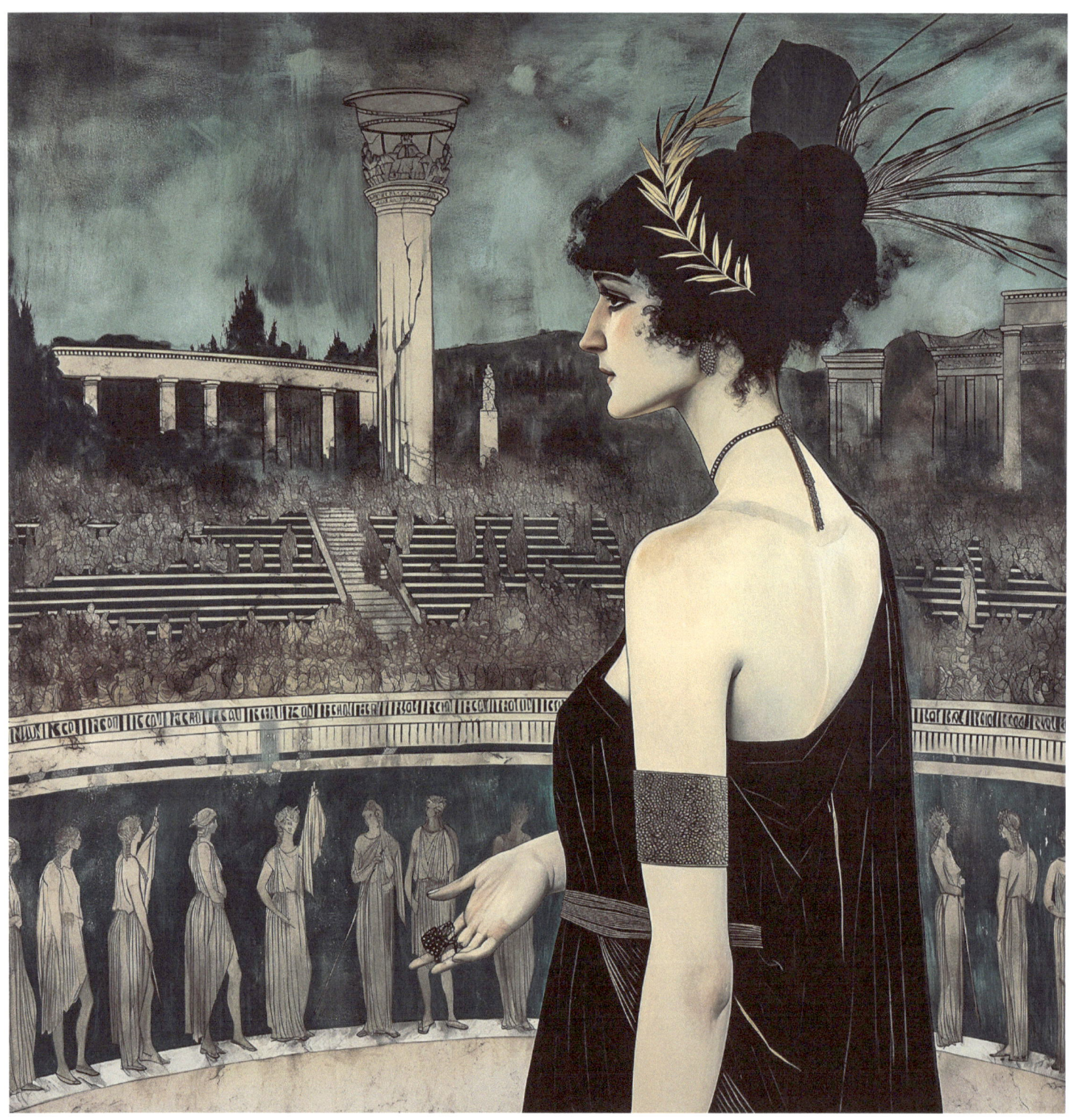

VIII

THE LATE ARRIVAL

Canny Artemis, here proclaimed most fair,
The king thus awaits, with a longing stare.
A herald calls, another entry rare,
Aphrodite enters, with Graces to declare.

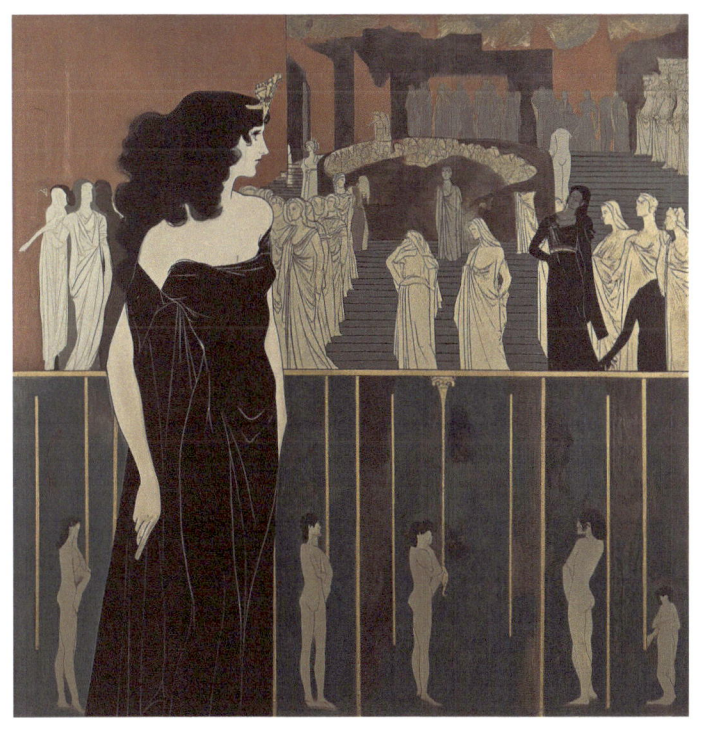
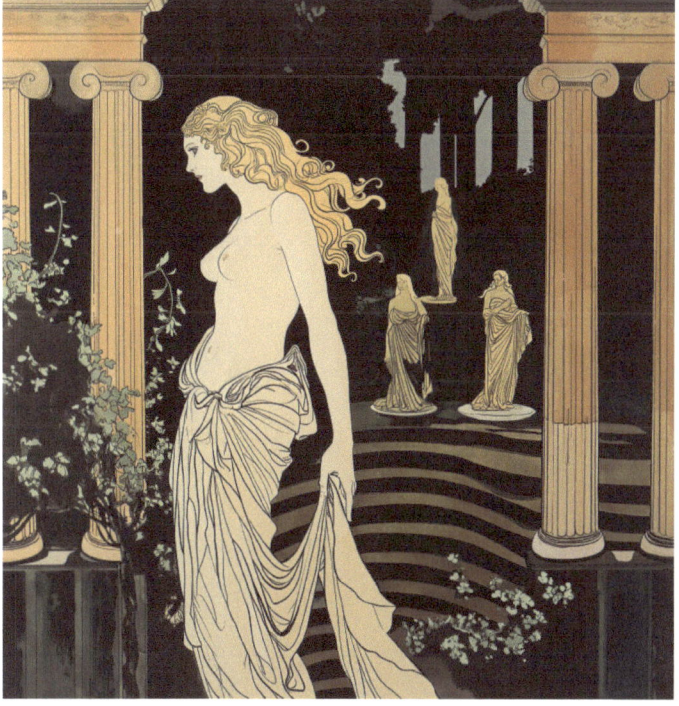

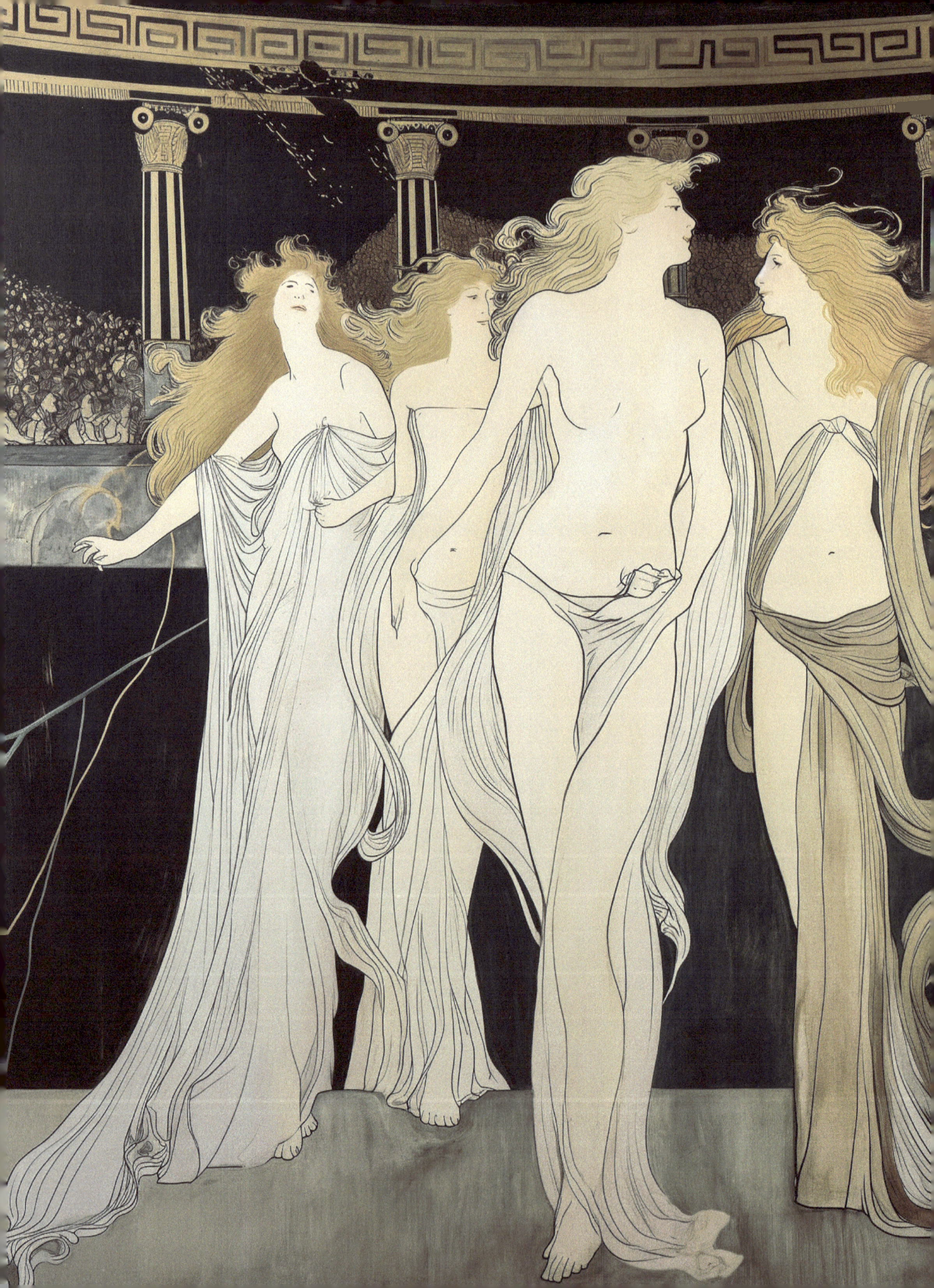

In the contest, she stands confident, proud,
Her attendants, the fairest in the crowd.

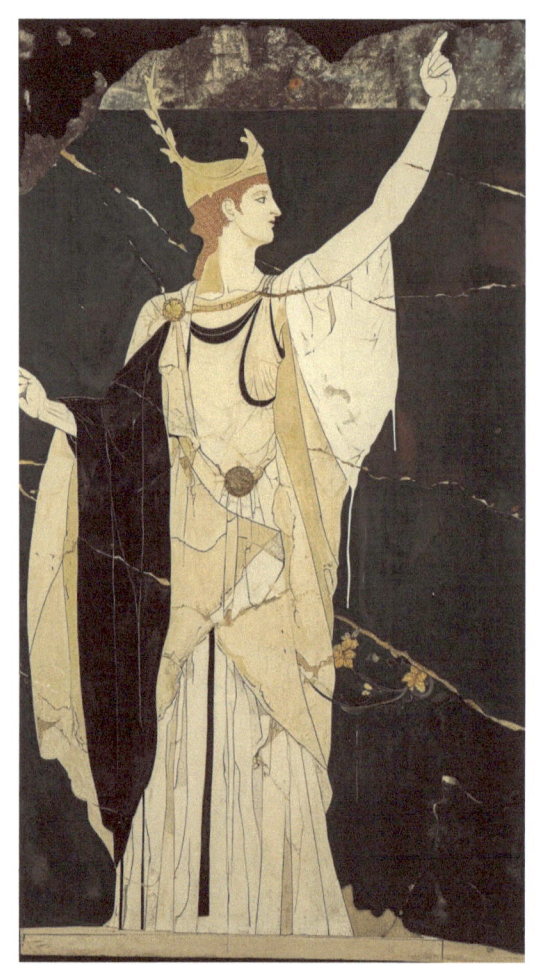

The finale declared, in voices loud,
Aphrodite triumphs, beauty endowed.

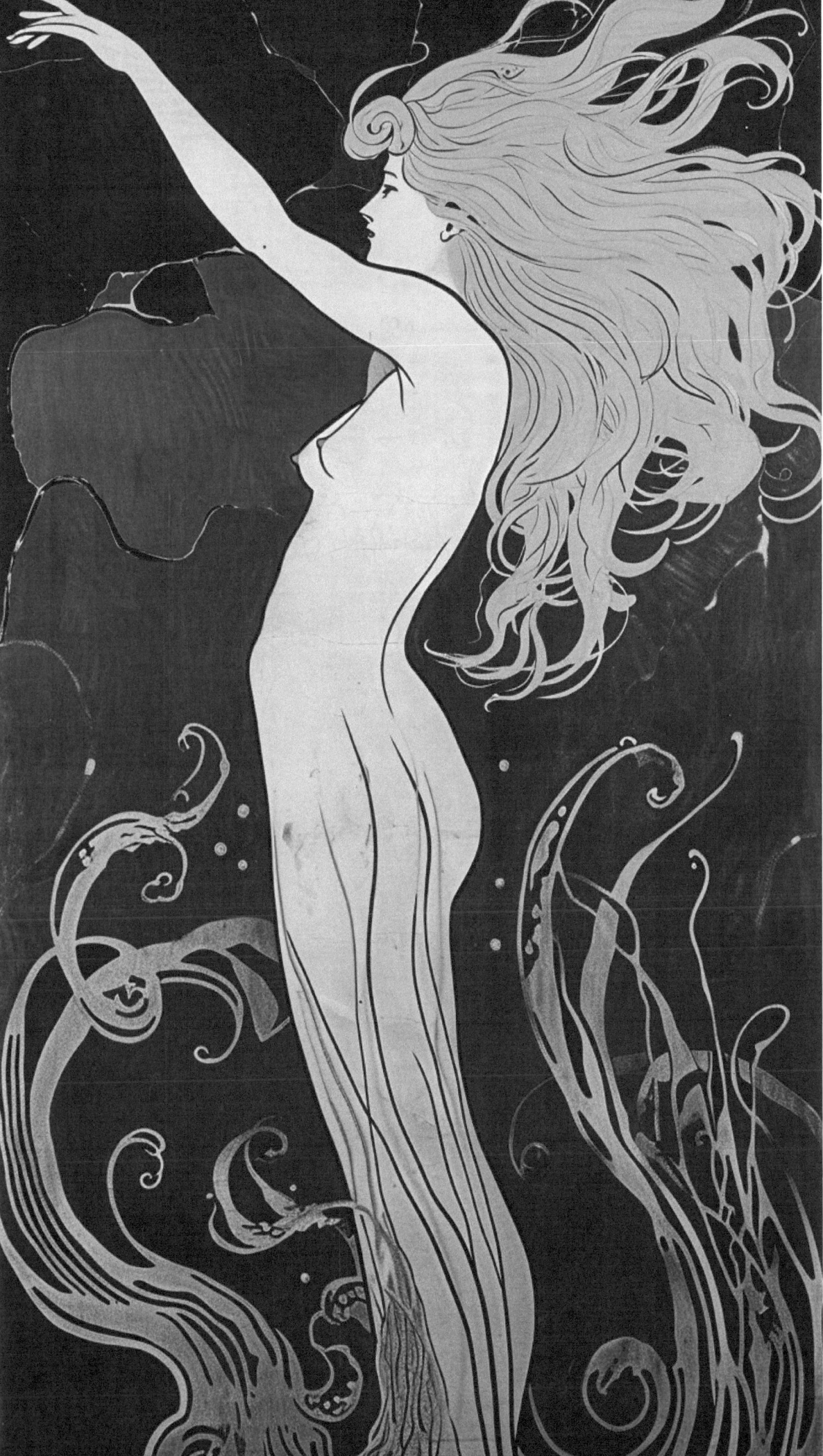

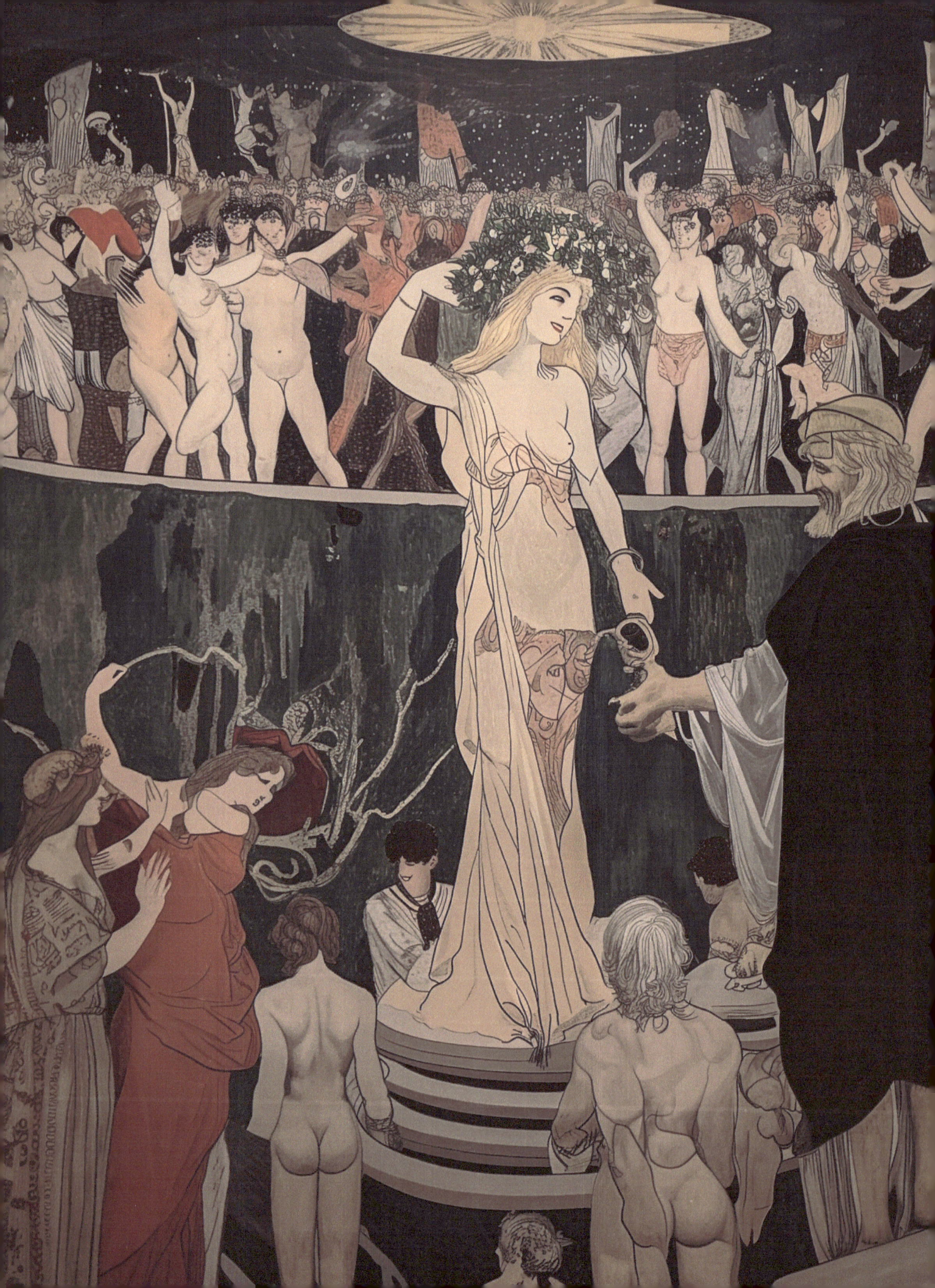

Noble Hellas, with gods and myths so grand,
A timeless tale of beauty, strife, and stand.
In poetic verses, on history's strand,
Aphrodite reigns, in beauty's command.

END

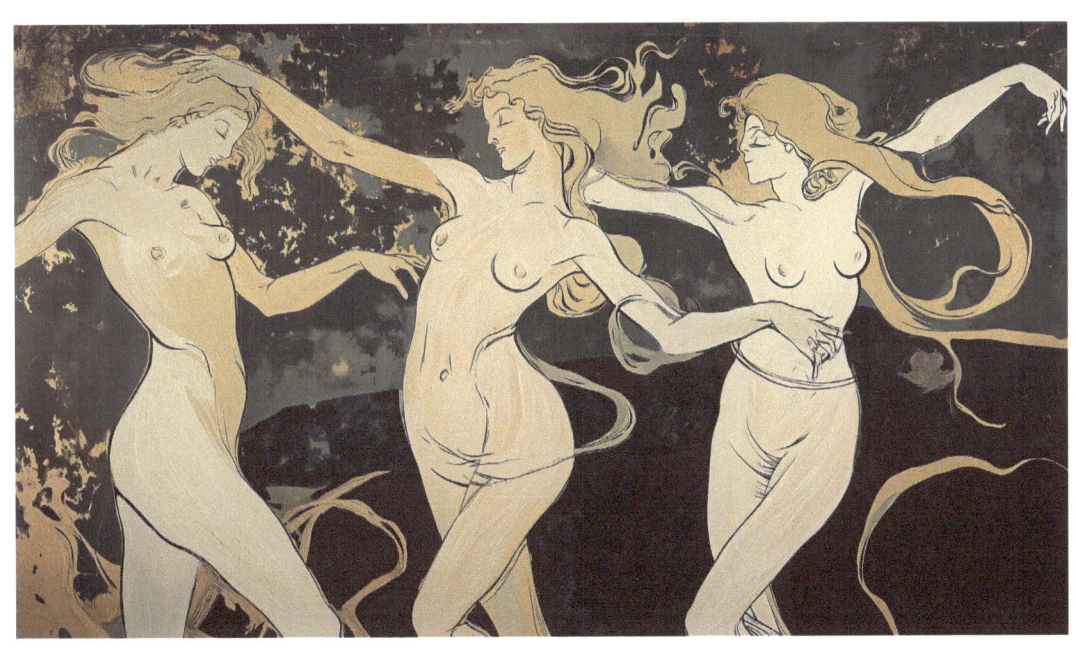

the THREE GRACES

www.ingramcontent.com/pod-product-compliance
Lightning Source LLC
Chambersburg PA
CBHW041317180526
45172CB00004B/1129